The Novel
of Nonel
and Vovel

Oreet Ashery
Larissa Sansour

The Novel of Nonel and Vovel

CHARTA

Contents

OREET ASHERY

ALSO KNOWN AS: NONEL
BORN: WEST JERUSALEM
NATIONALITY: ISRAELI & BRITISH
BASED IN: LONDON
SIBLINGS: BROTHER & SISTER
EDUCATION: FINE ART
MOVED TO ENGLAND: 19
CITY: LEICESTER
PROFESSION: ARTIST

LARISSA SANSOUR

ALSO KNOWN AS: VOVEL
BORN: EAST JERUSALEM
NATIONALITY: PALESTINIAN & RUSSIAN
BASED IN: COPENHAGEN
SIBLINGS: BROTHER & SISTER
EDUCATION: FINE ART
MOVED TO ENGLAND: 15
CITY: NORTHAMPTON
PROFESSION: ARTIST

Foreword

If dialogue were a biblical character, it would most probably be a well-nourished angel dangling innocently beneath a shining halo. Dialogue always leads to something good. And the few times it doesn't, at least we've somehow come to understand each other better. That, at any rate, is the general perception.

The Middle East, however, is its own reality. As most people familiar with the region will probably agree, dialogues between Palestinians and Israelis aren't all they are cracked up to be. In the eyes of most Palestinians, not only is it all talk and no state: often, dialogue serves as a smoke screen masking the creation by the occupying power of new and increasingly brutal facts on the ground — eventually rendering Palestinian hopes of a viable state all but futile.

Whenever the international community irons yet another tablecloth for yet another negotiating table, the Israelis systematically betray the diplomatic efforts by killing more Palestinian civilians, grabbing more land, demolishing more houses, erecting more illegal settlements, and sealing off an entire population from the rest of the world.

Nonetheless, outside spectators can think of nothing more appealing than a dialogue between a Palestinian and an Israeli. The face-to-face encounter between two presumed antagonists gives people the comforting idea that there are good people on both sides. A mutually extended olive branch is about as sexy as it gets.

Fully recognising the value and dire necessity of constructive dialogue, many Palestinians do not share the international community's eagerness to promote dialogue simply for the sake of dialogue. For many, the blind pursuit of dialogue — be it political, academic, or cultural — often runs the risk of obscuring the nature of occupation. It creates a dangerous aura of moral equivalence between the occupier and the occupied.

Although political by default, this book does not constitute any attempt to compromise political views in order to establish common ground for further negotiations. Nor does it embody any attempt to reconcile opposing opinions. In our case, consensus was already established prior to the initiation of the project. Both artists involved in this project are on the same page when it comes to Israel's savage occupation of Palestine — with only a faint Israeli minority sharing these views.

The consequences of this occupation will continue to influence Palestinian identity for generations to come. The end of occupation will merely mark the beginning of a long reconstructive process for Palestinian society as such and its eventual liberation.

One important aim of this book is to address the problematic nature of the very kind of dialogue we — as collaborating artists from opposite sides of the divide — are in some shape or form engaging in.

Introduction

In the summer of 2007, we agreed in principle to jointly produce our own version of a graphic novel. It made sense for us to work together, as our interests and means of production overlap and intersect in a number of ways. We've both been committed to engaging with the politics of the Middle East as an integral part of our art practice for many years, and both of our practices employ humor and reference popular culture critically in order to make contentious issues more accessible and further complicate them. Also, we both use ourselves — and occasionally our families — in our video, photographic, and performance work.

In addition to our professional similarities, not only were we both born in Jerusalem and raised in Palestine/Israel, we also emigrated from the region to London at a young age and hence share experiences on that note.

After the initial decision was made to create a graphic novel, we started developing a suitable concept. The first step was the creation of our respective alter egos: Nonel and Vovel. Both names are typos of the word "novel" from our initial Skype conversations, commonly laden with spelling mistakes.

The characters Nonel and Vovel quickly came to represent our semi-fictional stance in the world: two politically engaged, well intended, hard-working artists, who at times struggle to reap the financial and political rewards of their labour. A pair of borderline anti-heroes, you might say – or perhaps even, for poetic impact, losers.

As the characters had established themselves, *The Virus Story* soon followed. *The Virus Story* is written with few or no actual action scenes and is predominantly conversation based. Favouring the conversational mode was, to a large extent, an attempt to counteract the conventional genre of the action-packed comic book and approximate the anti-heroic nature of Nonel and Vovel. We wanted a story that was grounded in our domestic and urban everyday lives. We were simply curious to see what narratives would emerge when visual artists, such as ourselves, decided to create a graphic novel.

In *The Virus Story,* the Lab Man poses a big question to the two artists: would they be willing to give up their creativity in exchange for real powers? The poignancy of this question rests on the presumption that, traditionally and historically, artists do, in some shape or form, aspire to make a difference beyond their artistic practice by contributing to the notion of progress and facilitating new ideas and new meanings. However, by posing his question, the Lab Man suggests that art, even if politically engaged, does not hold any currency in the real world. In our story, the artists reject these real powers and choose to remain artists – only to find out the choice is no longer theirs to make. By sheer mutational circumstance, they have to become superheroes and leave their lives as artists behind. Coming to terms with their predicament, however, they decide to utilise their newfound, but yet unexplored, powers to save Palestine.

In order to accentuate the process and deliberations behind the book – as well as comment on the fact that our individual artistic practices, as it is the case with most artistic practice, more often than not do incorporate the work of others – we decided to have the various chapters of *The Virus Story* illustrated by different artists. This approach, we thought, would also ensure that the representations of Nonel and Vovel could shift according to the individual artists' interpretations, rather than having the same look throughout the book. With that in mind, we simply approached artists whose work we liked and tried to suit the nature of the written sequences to the style of each artist.

The second part of the graphic novel is an altogether different experiment. From having written the first part ourselves, we decided to facilitate and hand over the second part of the story – subsequently entitled *Intergalactic Palestine* – to the writer Søren Lind and the illustrator Hiro Enoki.
This was done partly as a kind of humorous reaction to the question of artistic disempowerment at stake and subsequent loss of creativity in the first part of the book and partly in order to have Nonel and Vovel metamorphose in style into their heroic incarnations and perform the required heroic acts suited for the ensuing superhero narrative. We were more than intrigued to realise that the abandoning of Nonel and Vovel's creative powers and their metamorphosis into superheroes has actually resulted in a well crafted action-packed comic style – the very same style that we were intentionally deconstructing in *The Virus Story.*

In fictional and visual terms – and much to our own surprise – while *The Virus Story* establishes the characters and the narrative grounds, as well as posits grave questions

regarding artistic agency, our heroic portrayal in *Intergalactic Palestine* has turned out to grant the both of us a sense of empowerment with respect to the prospect of both personal and political manifestations in the future.

From the onset, we never felt content with the notion of a fictional graphic novel alone, but also wanted the process behind the book to be transparent and grounded in our daily reality. Alongside the story of Nonel and Vovel, we proceeded to take a series of photographs in relevant locations in Palestine and London – including a checkpoint in Bethlehem, the Israeli wall in Palestine, the Royal Free Hospital in London, Doris Salcedo's piece *Shibboleth* at the Tate Modern, the Imperial War Museum, a Lebanese restaurant on Edgware Road, a London bus ride, and a Sunday roast meal.

These locations were chosen as precursors and instigators of directly related conversations between us, touching upon subjects such as the occupation of Palestine, coming to England, health, art and politics, war, Orientalism, and the nature of our collaboration. These seven psycho-geographic topics exist as graphic and photographic chapters alongside the fictional comic strip in order to create a multilayered approach to the narratives proposed.

The photograph of us sharing a bus ride – entitled *Normalisation* – is the precursor to the chapter dealing with the lengthy process of negotiating our collaboration. Over the course of many months, we have explored various models and ways of representing this subject. At one point, we tried posing five questions to each other regarding our feelings and views about this collaboration, which we both answered in detail, but eventually felt compromised by. We also thought to only print the reactions and feedback we received from people who had read those questions and answers – as perhaps more telling. But these reactions, alas, seemed out of context on their own. At a later stage, we toyed with the idea of printing blank pages, at times when we felt that our own conversation had gone blank, and even played with the option of printing two parallel books when we could not agree on certain things. Lastly, we tried scripting a fictional discussion of our thoughts, but this also did not prove wholly satisfactory. The way we decided to finally represent this collaborative process is the result of this discursive ride as well as the one that works best for us in the context of the book as a whole.

In the last stages of the project we discussed with the curators and writers Reem Fadda and Nat Muller the possibility of them reflecting on the book and contributing their response to the material in the form of a written text. By the end of our conversations, the idea of a distant future and its relation to the present and the past had captured our mutual interests, as Fadda's and Muller's texts included in this book both show.

This book does not contain individual art works as such. Instead, the digital images, the photographic snapshots, and the comic strip sequences, together with the content and structure of the book, make an art work in itself.

In the process of creating this book, certain possibilities and constructs, both fictional and non-fictional, of the hopefully not too distant future have emerged. In the dark shadow of an ongoing brutal occupation that must end, these possibilities and constructs make us both feel even more determined to pursue our artistic and political agendas as well as, even if ever so slightly, more optimistic.

Oreet Ashery and Larissa Sansour
March 2009

Chat History with larissa sansour | can we try to haev a..
(#oreetpoh/$lariksansour;18b725033c8d0cd8)
Created on 2007-10-22 18:24:43.

2007-10-22

oreet ashery:

17:19:23
can we try to haev a conversation?

larissa sansour:

17:19:43
yes, i think it is working.

oreet ashery:

17:19:57
great, shall we start? is it a good time for you?

larissa sansour:

17:21:17
yes, the time is good. the only thing is that i don't have any preparer questions. But maybe it is better that way.

oreet ashery:

17:21:29
i dont either...

oreet ashery:

17:21:57
what did you do in NY?

larissa sansour:

17:22:24
I had to give a lecture at the International Centre of Photography

oreet ashery:

17:22:32
what about?

larissa sansour:

17:22:58
about art and politics and weather art in any way coud be used as a political tool

oreet ashery:

17:23:37
do you think it can?

larissa sansour:

17:24:08
Sometimes I think it can and other times I feel I am wasting my time.

oreet ashery:

17:25:59
i went to a lecture by about body art adn how blood letting can create empathy in the viewer and how that can be a political tool, but I don't' think blood lettting meant to create empathy and i am not sure about evoking empathy as a political tool in any case...

<u>larissa sansour</u>:

17:48:01
I often get asked if I make political work becasue it is trendy. the first time i heard that i was really shocked. For me it is not just an uneasy topic at a dinner conversation.

oreet ashery:

18:25:48
and do you know when you are coming?

<u>larissa sansour</u>:

18:26:03
i am thinking of booking a ticket late at night on th 27th and then we can meet on the 28th

oreet ashery:

18:26:36
yes, we can meet any tiem on teh 28th

<u>larissa sansour</u>:

18:26:58
yes, let's do another conversation. and mayb think of something that could work in the nonel.

oreet ashery:

18:27:44
i think i need to know a bit more about your general life and your work in order to generate more thoughts re teh vovel

oreet ashery:

18:28:05
nonel adn vovel are great names fro the novel

PART 1

THE VIRUS STORY

CHAPTER 1

Green Tongue

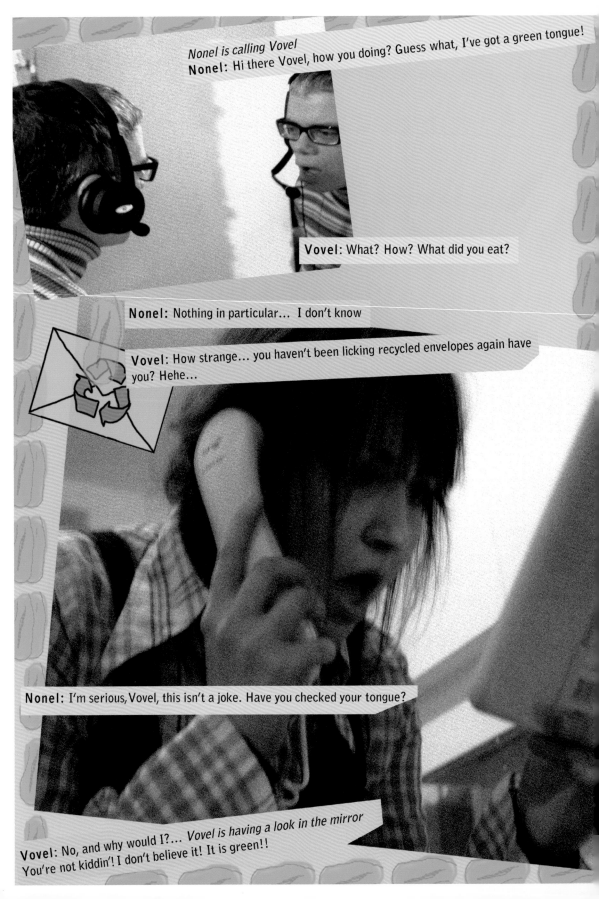

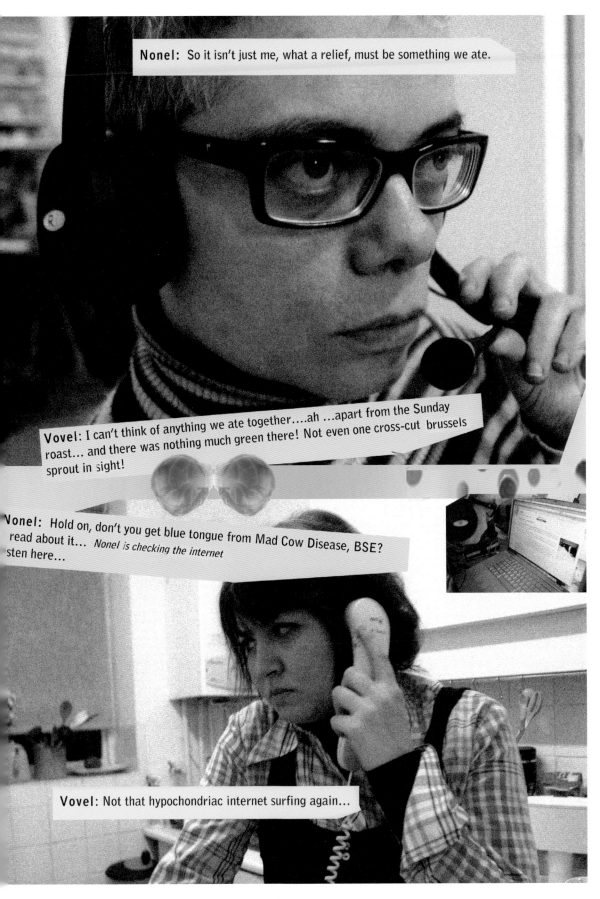

Nonel: Listen here…"Member of the foot and mouth…the BTV (Blue Tongue Virus) is from the genetic family of the African Horse Sickness (AHSV) and Epizootic Haemorrhagic Disease of Deer (EHDV)"… shit we should call the doctor!… this stuff sounds lethal…

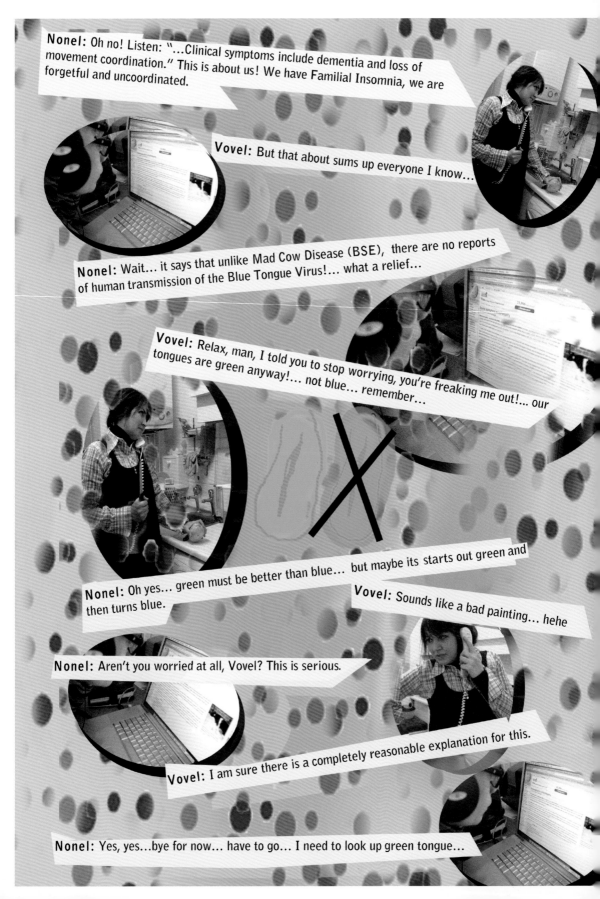

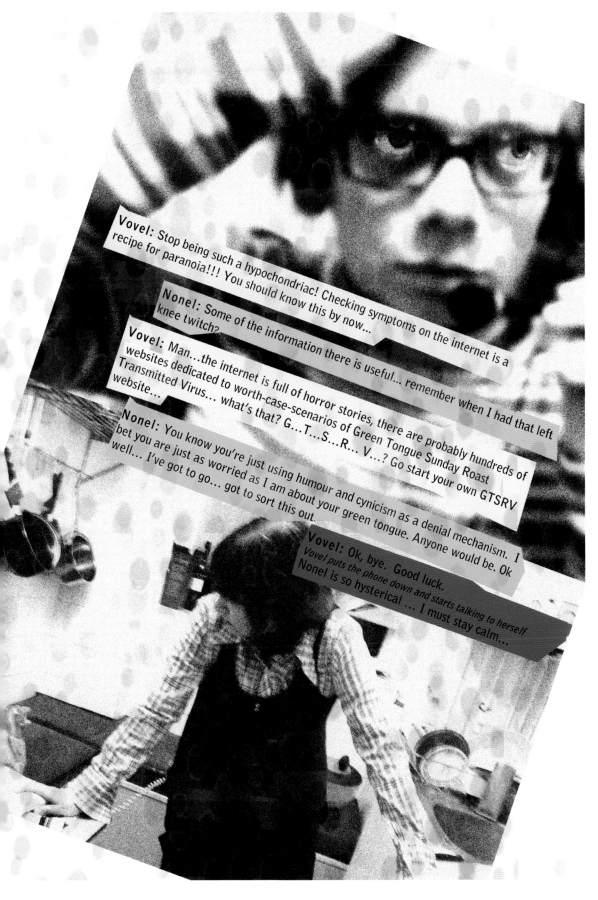

Vovel: Stop being such a hypochondriac! Checking symptoms on the internet is a recipe for paranoia!!! You should know this by now...

Nonel: Some of the information there is useful... remember when I had that left knee twitch?

Vovel: Man...the internet is full of horror stories, there are probably hundreds of websites dedicated to worth-case-scenarios of Green Tongue Sunday Roast Transmitted Virus... what's that? G...T...S...R... V...? Go start your own GTSRV website...

Nonel: You know you're just using humour and cynicism as a denial mechanism. I bet you are just as worried as I am about your green tongue. Anyone would be. Ok well... I've got to go... got to sort this out.

Vovel: Ok, bye. Good luck.
Vovel puts the phone down and starts talking to herself
Nonel is so hysterical ... I must stay calm...

The Sunday Roast

THE ENGLISH PHASE

nonel and vovel sunday roast london

It's great that we could meet up for lunch.

YEAH, I'M REALLY HAPPY YOU MADE IT.
I CAN'T BELIEVE YOU NEVER HAD A
SUNDAY ROAST BEFORE!

I don't know, maybe it's because I always
stayed in at the boarding school on Sundays,
I do remember my English friends mentioning
it every time they went off to meet their
parents on Sundays, but I never had it myself.

HOW DID YOU END UP IN A BOARDING
SCHOOL HERE? WHERE WAS IT? DID
YOU COME HERE ON YOUR OWN?

Yes, I did. During the first Intifada all high schools closed in Palestine and parents who could afford to, sent their children abroad to continue their education. So, I was sent to Northampton.

NORTHAMPTON? HOW OLD WERE YOU?

15

MMM, SO YOU ARRIVED AT NORTHAMPTON AROUND THE SAME TIME AS I CAME TO LEICESTER

I GUESS so. I didn't know you were in Leicester. I thought you always lived here in London.

NO, I CAME TO LEICESTER IN 1987. I WAS MARRIED TO AN ENGLISH RUGBY PLAYER FROM LEICESTER I MET IN A KIBBUTZ. I WAS IN SHOCK BY THE FACT THAT I LEFT EVERYTHING BEHIND. IT TOOK ME A REALLY LONG TIME TO FEEL SETTLED HERE.

It sounds familiar. I left Palestine in 1988. The boarding school I was attending was relatively freer than other schools, no uniforms and that kind of thing, but still it was hard.

SUNDAY ROAST

with roast veg.

yorkshire pudding

and gravy

YEAH, WHEN I FIRST ARRIVED IN ENGLAND, I WAS 20 AND EVEN THOUGH I MADE THE DECISION TO LEAVE ISRAEL, THE CHANGE WAS HARD. I WAS LIVING WITH MY BACK THEN HUSBAND'S FAMILY THAT WAS SO 'ENGLISH'. IT WAS NOTHING LIKE THE WARMTH I WAS USED TO. THE WHOLE EXPERIENCE FELT UNREAL.

THIS IS WHERE I'VE LEARNT HOW TO CUT A CROSS ON THE BRUSSELS SPROUTS.

I understand what you mean about the lack of emotional warmth. I was always physically freezing in that school and hungry. I remember how they restricted the amount of biscuits we were allowed to have at tea-time. The whole experience reminded me of Charles Dickens' Oliver Twist. To rub it in even more, we had to read Charles Dickens for our literature class.

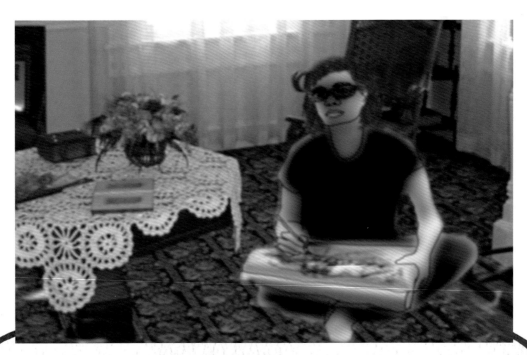

Ha...Ha. YES THAT SOUNDS TRULY
MISERABLE. IT SOUNDS LIKE YOU HAD
TO GROW UP VERY QUICKLY. I WAS
SO UNHAPPY DURING THAT TIME
AND WOULD NOT LEAVE THE HOUSE
MUCH, THE ONLY THING THAT
SAVED ME WAS DRAWING EVERY DAY.
SO EVERYDAY I WOULD DRAW A
DIFFERENT CORNER OF THE LIVING
ROOM AND AFTER A FEW MONTHS
I HAD A PORTFOLIO AND GOT
INTO AN ART COLLEGE

That really conjures up a dreary image in my head. I am glad we are meeting in London now under very different and much more cheerful circumstances! I am excited about our little project.

By the way, isn't the Sunday roast supposed to be a dinner thing?

NO, THE SUNDAY ROAST IS AN AFTERNOON THING, AFTER WHICH THE MEN SIT AND WATCH RUGBY AND THE WOMEN CLEAN... HEE.. HEE... THAT IS HOW IT WAS IN LEICESTER 1987...

Ha ha, that sounds very traditional.

YES, SUNDAY ROAST HAS MOVED A LOT SINCE THE 1980S, BUT I AM NOT SURE THAT THIS PARTICULAR ONE HAS... HEE... HEE...

mmm... Let's taste it anyway.

CHAPTER 2

The Lab Calls

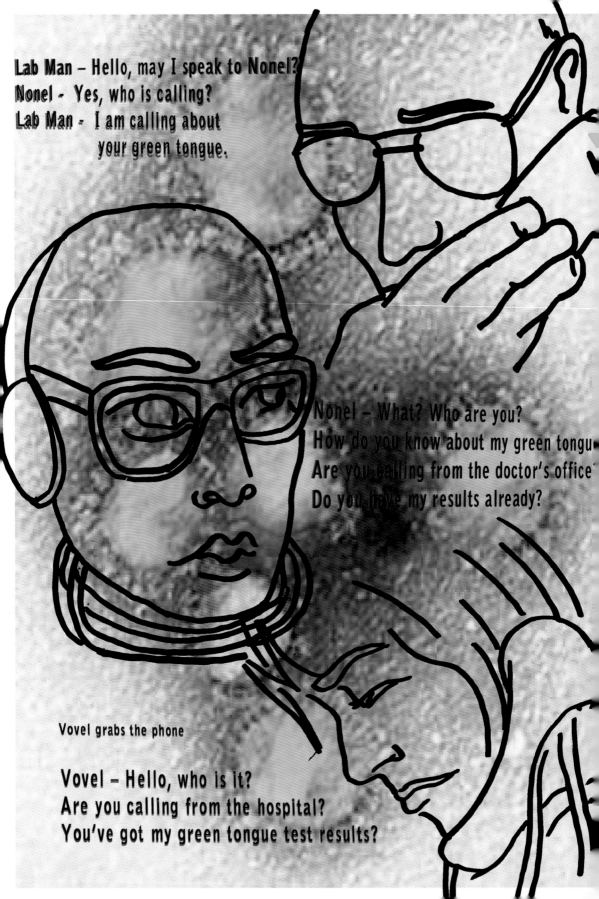

Lab Man – Listen guys, I'm not from the hospital, and I am not from your doctor's office. This is not for the phone, lets meet up and I promise you all will become clear.

Vovel– Is this some kind of prank? A candid camera wind-up? Or perhaps a cringe TV advertising campaign? 'Eat this chocolate bar and you might win a green tongue'? Because if it is it's not working for us!

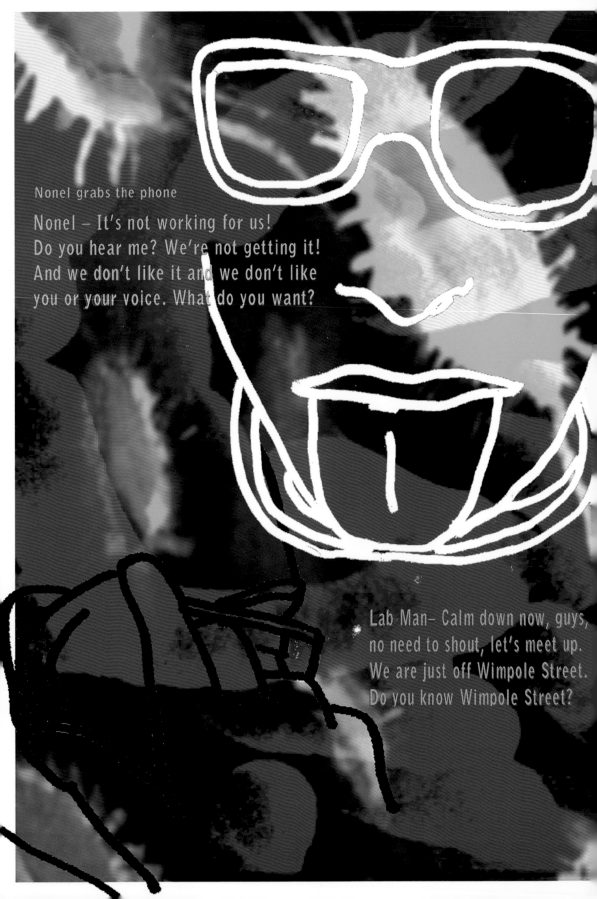

Normalisation

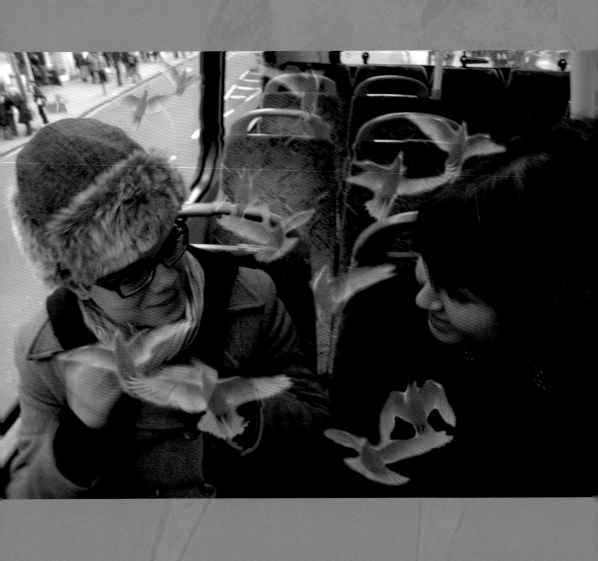

Collaboration Questionnaire

1. Name:

2. Nationality:

3. Artistic practice:

4. Have you ever before collaborated with a Palestinian?

□ yes □ no

Explain:

5. I believe this project is likely to be seen by Israeli audiences as:

(feel free to add your own adjectives)

□ sexy	□ bold	□ necessary	□ naïve	□ cool	□ courageous
□ silly	□ elitist	□ childish	□ pointless	□ important	□ interesting
□ funny	□ too much	□ annoying	□ lame	□ cute	□ constructive
□ clever	□ pretentious	□ adorable	□ outrageous	□ biased	□ treacherous
□ encouraging	□ unethical	□ delusional	□ useful	□ good PR	□ confrontational
□ offensive	□ informative	□ worthwhile	□ promising	□ helpful	□ provocative
□ good for fundraising		□ counterproductive			

Explain:

6. I believe this project is likely to be seen by international audiences as:

(feel free to add your own adjectives)

□ sexy	□ bold	□ necessary	□ naïve	□ cool	□ courageous
□ silly	□ elitist	□ childish	□ pointless	□ important	□ interesting
□ funny	□ too much	□ annoying	□ lame	□ cute	□ constructive
□ clever	□ pretentious	□ adorable	□ outrageous	□ biased	□ treacherous
□ encouraging	□ unethical	□ delusional	□ useful	□ good PR	□ confrontational
□ offensive	□ informative	□ worthwhile	□ promising	□ helpful	□ provocative
□ good for fundraising		□ counterproductive			

Explain:

So why on earth are you doing it?

Date and signature:

Collaboration Questionnaire

1. Name:

2. Nationality:

3. Artistic practice:

4. Have you ever before collaborated with an Israeli?

□ yes □ no

Explain:

5. I believe this project is likely to be seen by Palestinian audiences as:

(feel free to add your own adjectives)

□ sexy	□ bold	□ necessary	□ naïve	□ cool	□ courageous
□ silly	□ elitist	□ childish	□ pointless	□ important	□ interesting
□ funny	□ too much	□ annoying	□ lame	□ cute	□ constructive
□ clever	□ pretentious	□ adorable	□ outrageous	□ biased	□ treacherous
□ encouraging	□ unethical	□ delusional	□ useful	□ good PR	□ confrontational
□ offensive	□ informative	□ worthwhile	□ promising	□ helpful	□ provocative
□ good for fundraising		□ counterproductive			

Explain:

6. I believe this project is likely to be seen by international audiences as:

(feel free to add your own adjectives)

□ sexy	□ bold	□ necessary	□ naïve	□ cool	□ courageous
□ silly	□ elitist	□ childish	□ pointless	□ important	□ interesting
□ funny	□ too much	□ annoying	□ lame	□ cute	□ constructive
□ clever	□ pretentious	□ adorable	□ outrageous	□ biased	□ treacherous
□ encouraging	□ unethical	□ delusional	□ useful	□ good PR	□ confrontational
□ offensive	□ informative	□ worthwhile	□ promising	□ helpful	□ provocative
□ good for fundraising		□ counterproductive			

Explain:

So why on earth are you doing it?

Date and signature:

A Crossword from the Holy Land

Down

1. A dip with a highly contested origin.
3. America's relation to Israel
4. What Monotheists turn into when they die
5. A transcended Islamic community
8. Biggest supporter of Israel
10. The number of days the war of 1967 took
11. A Semitic language
13. The Arabic word for the Palestinian catastrophe of 1948
15. Young Men's Hebrew Association

Across

1. A food that is neither Kosher nor Halal
2. A food that miraculously fell from the sky ages ago
6. An oriental God
7. Atomic Mass Unit
9. A popular Semitic animal
12. An unfortunate side effect of the religions of the book
14. One of the many things that Israel controls in the occupied Palestinian territories
16. A wise Muslim doctor with traditional remedies
17. An Islamic ruler
18. Three smart men who visited Bethlehem sometime ago

CHAPTER 3

The Bug Spilled

Lab- hi guys, we really appreciate you coming over ON such short notice, would you like a drink? Tea? Coffee?

v - yes some green tea please. Haha... (we thirst only for facts) no we don't want a drink, can you just get STRAIGHT strait to the point? please tell us what is going on with us?

n - why are we here? Who are you?

Lab - I understand you are keen to hear what we have to say, but you see, it is not that simple. Basically... well... to put it in simple terms, we are a kind of a researching company and we are developing a certain virus, a super bug if you like, which enhances human potential. It is a good bug! Not a bad bug.

v - Sounds very philanthropic! what's that got to do with our green toungles?

n - Let the man talk, vovel...

Lab — however, the virus is not fully developed yet, so we are not/sure **YET** what specific human powers are enhanced, as we have channelled 100 power potentials. At this point it could be all or ~~any~~ **NONE** of those.

n — what are you telling us?

v — I have a show opening in a week, I don't have time for this...

Lab - well you see, it is a little awkward, but you
artists must know what its like when things
spill over by accident, like oil painting...

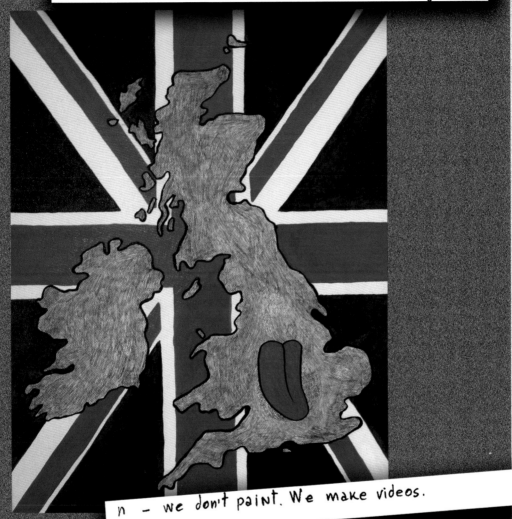

n - we don't paint. We make videos.

Lab - well, I am sure you've spilt coffee on your
keyboard at one point or another...
have you not?

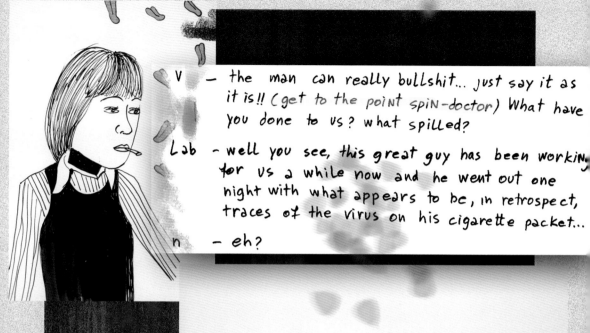

v — the man can really bullshit... just say it as it is!! (get to the point spin-doctor) What have you done to us? what spilled?

Lab — well you see, this great guy has been working for us a while now and he went out one night with what appears to be, in retrospect, traces of the virus on his cigarette packet...

n — eh?

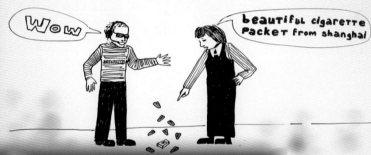

Wow

beautiful cigarette packet from shanghai

Lab — And it seems that you two have picked it up at the a gallery opening where you all accidentally met.

n — an opening? I don't go to openings... oh... Must be THAT opening of the Art&Politics show

v — yes... when we both had a good look at this beautiful cigarette packet from shanghai... remember? with the golden picture of the house and the birds on the lake...

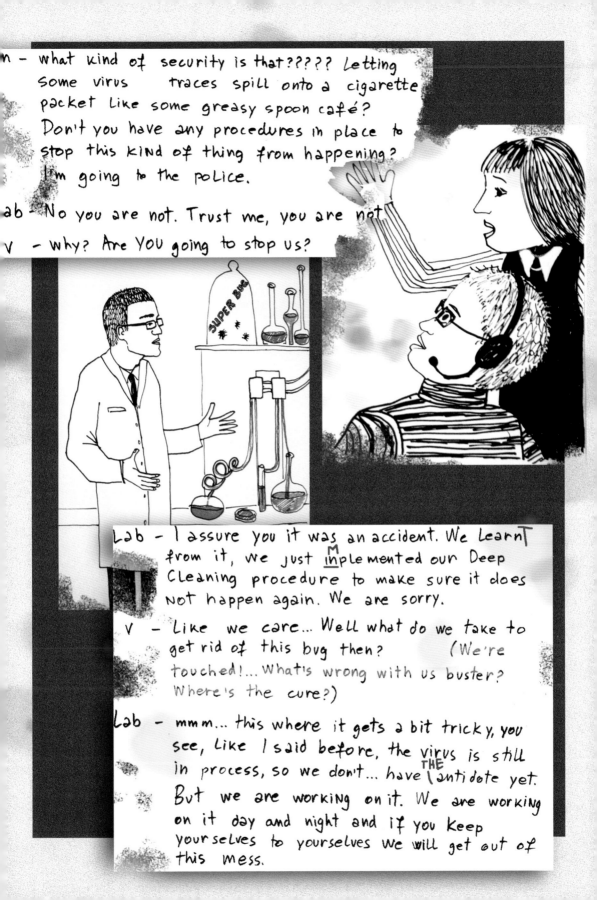

n – what kind of security is that????? Letting some virus traces spill onto a cigarette packet like some greasy spoon café? Don't you have any procedures in place to stop this kind of thing from happening? I'm going to the police.

ab – No you are not. Trust me, you are not.

v – why? Are YOU going to stop us?

Lab – I assure you it was an accident. We learnT from it, we just inplemented our Deep Cleaning procedure to make sure it does not happen again. We are sorry.

v – Like we care... Well what do we take to get rid of this bug then? (We're touched!... what's wrong with us buster? Where's the cure?)

Lab – mmm... this where it gets a bit tricky, you see, like I said before, the virus is still in process, so we don't... have the antidote yet. But we are working on it. We are working on it day and night and if you keep yourselves to yourselves we will get out of this mess.

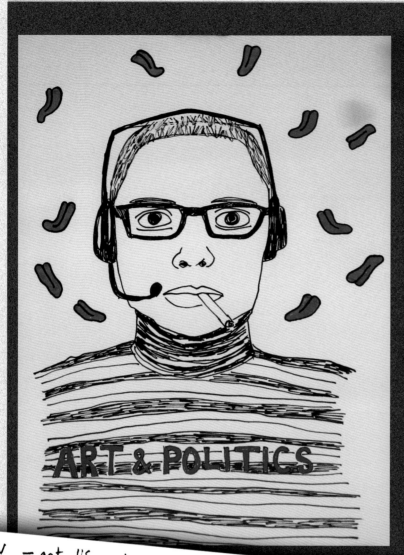

v — get US out of the mess? This is your mess.

n — tearful — what kind of symptoms should we expect? (what's going to happen... to us?...)

Art & Politics

WHEN NONEL AND VOVEL MADE

WORK ABOUT THE MIDDLE EAST

IN 2000

THEY WERE ASKED: WHO ARE

YOUR AUDIENCES?

WHEN THEY MAKE WORK ABOUT

THE MIDDLE EAST IN 2009

THE COMMON QUESTION IS:

DO YOU DO IT

BECAUSE IT IS TRENDY?

We came across this conversation on facebook. The exchange represents some of the current discourse on contemporary art and the Middle East.

All text is printed with the permission of the original contributors. Names and details have been changed.

Nandita is dismayed by survey art shows on entire continents, they are no more than ethnic pornography for no brainers... you know the show 3:20pm – Comment

Emmy Sharp at 3:56pm June 26
I am all there with you on that one...

Nandita Bhagat at 3:57pm June 26
yes it is interior decoration --- eeyyuk

Farid Khassis at 4:24pm June 26
Yup ... I expect to puke when I go to the show tomorrow. Pure hype.

Nandita Bhagat at 5:18pm June 26
'Shiny hollow people' cashing in on sensitivities – that describes the type of artists in this show – all except for Hormoz Suren – he deserves better than to be in this type of fun fair..

Farid Khassis at 2:10am June 27
It's depressing to see how artists are becoming increasingly complicit with curators and art dealers. That conference on the Middle East – which I think I clocked you at, but didn't want to risk pestering a stranger – really brought it out for me. Some panelists laid out a call to arms – or at least utensils – to artists, and how did they respond? By revoking to self infatuated and lazy debates over identity politics that have been played out since the 80s. It's a shame that 'committed art' has either become complicit aesthetically, or lazy in its politics.

Nandita Bhagat at 2:48am June 27
Oh and yes I did see u don't if u noticed me noticing you – We are showing this film we made in Palestine – take a look on my page here and u will find it – come if u like and I will put u on the door..

Emmy Sharp at 9:57am June 27
I'm planing to come and see your film

Nandita Bhagat at 10:56am June 27

I'm showing a few

Farid Khassis at 4:34pm June 27
I'm definitely on it ... look forward to finally meeting then. Off to that middle
east show on Thursday, so I'll let you know which piece I end up throwing up
on first ...

Nandita Bhagat at 3:16am June 28
I could tell u now which one u should puke on as one thing I abhor in these
sensitive times are people who use ones political empathy, love, money and
time to make self aggrandizing bombastic advancements. We will talk more
when we meet about this.

Farid Khassis at 3:39am June 28
Sounds good! Did you watch the Culture Show piece on it?! That painter
seriously annoyed me ... and his work looked pretty banal. Anyway.

Ammy Sharp at 10:19am June 28
just checked your page...I'm away☹

Farid Khassis at 12:37pm June 28
Well I can't pass complete damnation over the piece just from the images they
showed, but it was the one 'imagining' Palestinian 200 years from now, as a
giant shopping mall/theme park/amusement arcade, he was terrible when I
met him – same lazy and self-indulgent identity politics that has become
throughly neutralised today. But also the work perpetuated the same
hackneyed discourses over modernity – hedonistic culture in Israel. To be
honest, the way parts of the W. Bank are developing today they will become
neo-liberal paradises for some – that divide would have been interesting to
explore

Nandita Bhagat at 12:53pm June 28
Yes wow that is really horrible and sad. There are good things about it that
need a lot of time and a lot of development but it is sad that it has been
represented in such a way. When did art dealers ever care about the
complexities of identity – they just create divisions its all a form of cultural
imperialism.

Nandita Bhagat at 2:24pm June 28
but artists like that in the ME with no experience just follow the money and
think the bright lights are the answer – no solidarities and short memories.
But we must not generalise some do find a way to make meaningful work
about the situation in the region

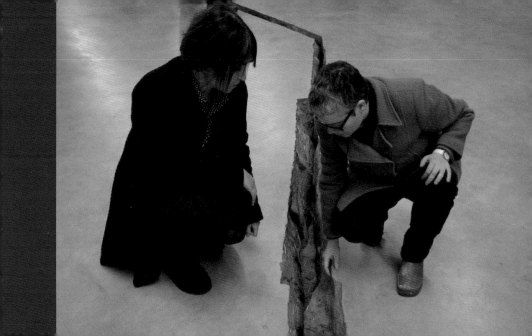

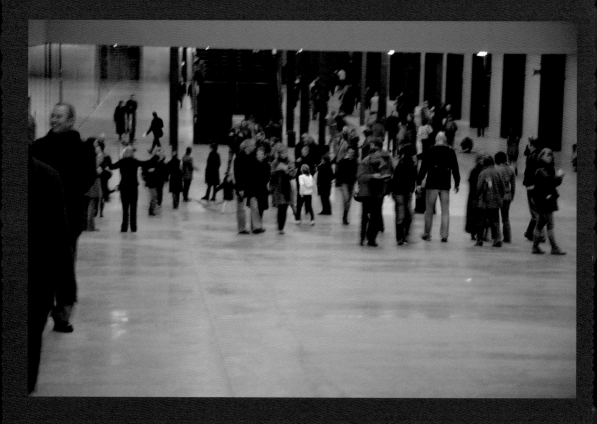

Tate Modern, Shibboleth, Doris Salcedo, 2007

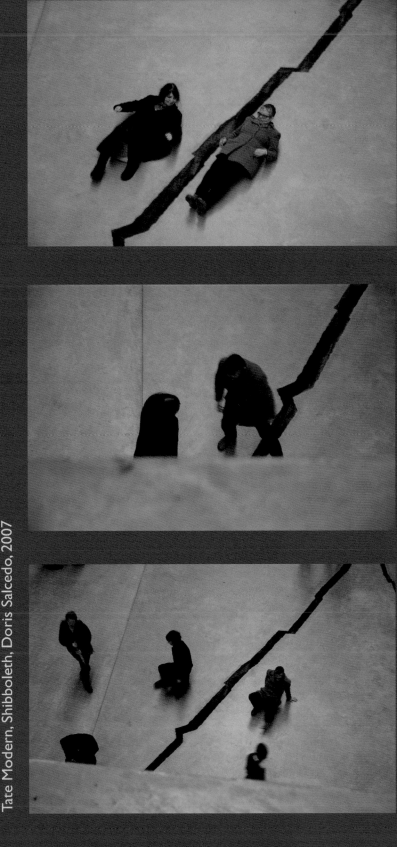

CHAPTER 4

Symptoms

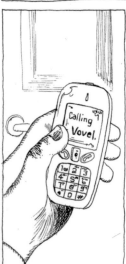

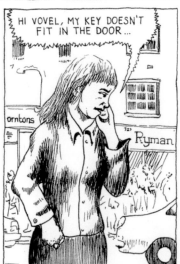

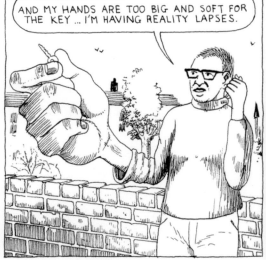

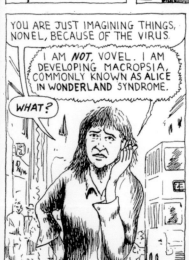

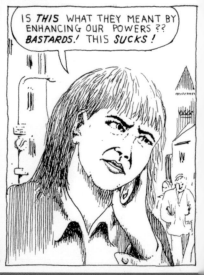

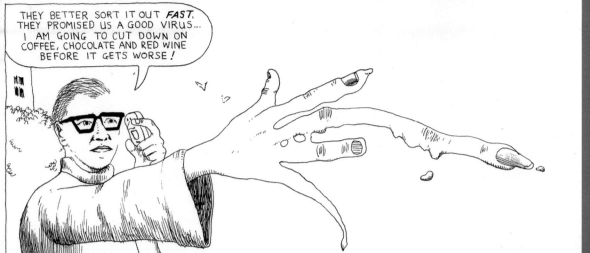

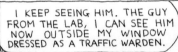

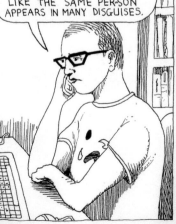

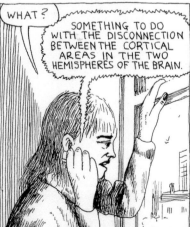

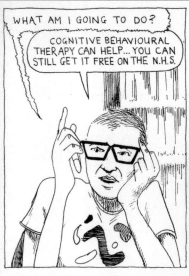

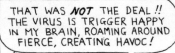

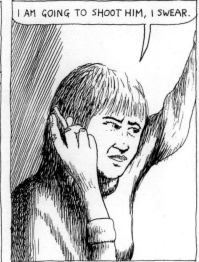

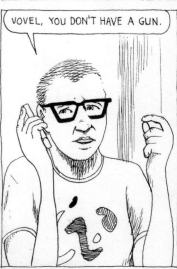

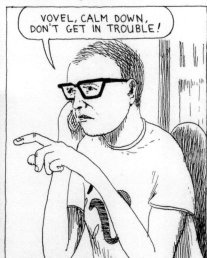

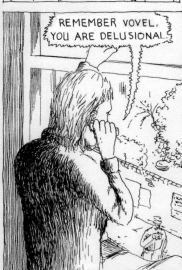

Art & Health

Sections from the research-
based essay "Making a
Living as an Artist"

Introduction

The term "artist" is readily accepted as an accurate job description. For many artists, howev-
er, the practical application of this term often refers to a single career that comprises a port-
folio of jobs; additional activities such as lecturing, curating, commissions, or part-time
employment that are used to supplement the income derived from making work.

This aspect of the arts profession is accepted as a condition of the job, but is often over-
looked. The idea of an entrepreneurial artist, adapting to encompass new roles in order to
make a living and further their practice, is often hidden by the necessity and desire to pro-
mote the creative aspects of the job.

Instead, the dominant images of bohemian artists accepting a life of struggle for the sake of
their work, or con-artists duping public bodies into paying for lavish jokes, still control the
perception of what it means to be an "artist." This invariably helps to create unrealistic
expectations about how a professional artist makes their living, and many people (artists and
non-artists) are surprised to learn that there is very little funding available for practitioners to
simply spend time making their own work . . .

Cultural Context

. . . A large proportion of those employed in the cultural sector are low-earners, self-
employed, or working under temporary contracts, yet the sector is seen as a source of quality,
dynamism, and almost perversely, as promoting economic growth[1] and regeneration.

"Artists are increasingly confronted by a pop world permeated by the interests of transnation-
al businesses, image-enhancing cultural forms, or competitively oriented city marketing.
Urban organisers in Berlin, for instance, have long since discovered the "young art scene" as
a factor enhancing the city's attractiveness and promote it accordingly."[2]

In this sense, artists, their ideas and their work are all tradable commodities within an eco-
nomic system that recognises the benefit of a vibrant cultural sector.

This assertion that artists are a force for regeneration can be seen throughout the UK in each
urban regeneration program that seeks artistic input and each national award that is spon-
sored by a business trying to align itself with the kudos of the art world. It is a position that
can be endlessly discussed, but in this context serves to highlight why art and economics can-
not be viewed as separate entities. As Santiago Sierra (an artist whose work examines the
exploitative nature of the global economy) states in an interview with Claudia Spinelli: "The
idea of the artist as a brilliant outsider is a myth that has outlived its time. Artists have long
since become global players who, like other producers, must assert themselves within the
value system of a worldwide economy."[3] Hans Abbing, an artist and economist, argues that
the ideal of the bohemian artist was invented by romanticism, which turned artists from
skilled artisans into the purveyors of authenticity.[4] "Beginning with the Renaissance and up to
romanticism, some artists were held in high esteem but they did not offer an alternative to
the bourgeois lifestyle, which was firmly implanted in the world of business and commerce.
However, over the last one hundred and fifty years artists and the arts have become symbols
of an alternative to the bourgeois lifestyle. It was a romantic, not realistic alternative; and
this probably added to its allure."[5] This is often translated to mean that artists have to suffer
for their work in order to preserve their autonomy and therefore authenticity, to the extent
that it has become part of our general education.[6] In effect, a line has been drawn between
the "commercial" and "non-commercial" artist, which states that one is to be looked down
upon, the other held in the highest esteem.

Although this is a very simple presentation of a complex argument, it does highlight a key
area of the arts market, which is the buying and selling of "authenticity." Both art and eco-
nomics are symbolic systems where values are attached. The trading of cultural objects is the

trading of cultural knowledge – the non-materialistic qualities of ideas, values, desires, and information.[7] This allows the purchaser to acquire "symbolic profit,"[8] a clear statement about themselves and their social standing. In contrast, to place an economic value on a piece of work devalues that work and the artist who created it: "once art is priced it is compared with other art and other consumer goods."[9]

In the same way, if the arts become just another profession, artists will be comparable to everyone else and therefore loose their authenticity, making it far more attractive to caricature the struggling artist than a highly educated professional with bills to pay.

Following this line of argument, it is clear that the artist is in a no-win situation. To be considered a "true" artist, they must suffer for their work (i.e. an object, experience, service, etc.) yet to be able to work, they must be able to survive. The most logical way to do this is by selling work, but placing a price on the value of their work devalues that work and questions the validity of their claim to the term "artist." Determining a daily rate, fee, or price then becomes more than just a calculation of costs, but a judgment of artistic integrity.

It is impossible to find the answer to this problem, which is ingrained throughout various systems, and which may not want to be solved. But it is possible to look at the working lives and attitudes of artists to see if these theories bear any resemblance to day-to-day life, and examine some of the strategies artists have developed that allow them to exist within such systems.

Matters Arising

. . . From these conversations, I also feel it would be productive to continue exposing the realities of making a living as an artist. At the risk of destroying some of the glamour and mystique, replacing the image of the bohemian artist suffering for their work with one of a hardworking, committed, and, above all, valuable addition to society, will help to produce a better understanding of what it means to be an artist and perhaps help improve payment practices.

1. Galloway, S, Lindley, R, Davies, R, Scheibl, F, *A Balancing Act: Artists' Labour Markets and the Tax and Benefit System.* Warwick: University of Warwick, 2002, p. 13.

2. Luckow, Dirk, "On (Un)-Thinkable Co-operations Between Art and Economics: 'Economic Visions'", in Cantz, H (ed.), *Art and Economy.* Hamburg: Deichtorhallen Hambourg & Siemens Art Programme, 2002.

3. Spinelli, Claudia, "Artists as 'Exploiter': Santiago Sierra", in Ibid.

4. Abbing, Hans, *Why Are Artists Poor? The Exceptional Economy of the Arts.* Amsterdam: University of Amsterdam, 2002, p. 26.

5. Ibid.

6. Ibid., p 89.

7. Felix, Z, Hentschel, B, Luckow, D, in *Art and Economy, Op. cit.,* p. 242.

8. Bourdieu, P, *Distinction: A Social Critique of the Judgement of Taste.* London: Routledge, 1979, p. 270.

9. Abbing, Hans, *Why Are Artists Poor? The Exceptional Economy of the Arts, Op. cit.,* p. 22.

First published: Research papers December 2006, a-n Publications.

Royal Free Hospital, London

Royal Free Hospital, London

vovel's daily supplements

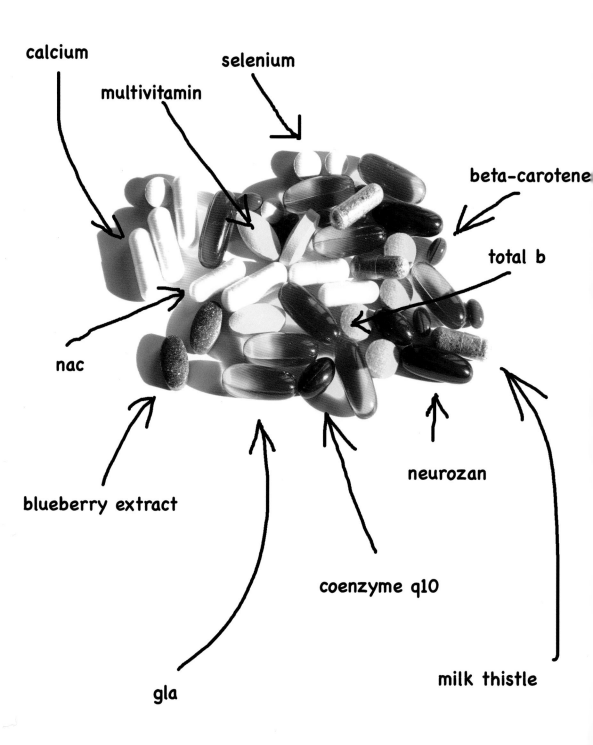

calcium

multivitamin

selenium

beta-carotene

total b

nac

neurozan

blueberry extract

coenzyme q10

gla

milk thistle

coenzyme q10: has powerful antioxidant effects and destroys free radicals in the body.

total b: enhances immune and nervous system function and promotes cell growth and division. it also combats the symptoms and causes of stress and depression.

blueberry extract: a powerful antioxidant that improves memory and mental clarity.

multivitamin: combats stress and energizes. can also reduce the risk of cancer and cardiovascular disease.

gla: one of the main essential fatty acids. it is important for the regulaiton of a host of bodily functions such as nerve transmission.

beta-carotene: a very powerful antioxidant that is beneficial for the heart and circulatory system. maintains healthy skin and good vision.

neurozan: promotes brain function and prevents the damage of brain cells.

calcium: essential for the maintenance of vital body processes. important for healthy bones and teeth.

selenium: its antioxidant properties help prevent cellular damage from free radicals.

nac: is a powerhouse of a supplement with potent antioxidant activity. it helps fight viral infections, detoxify the liver and build connective tissue.

milk thistle: has protective effects on the liver and greatly improve its function. good to take after too many art openings.

nonel's daily supplement

vitamin c

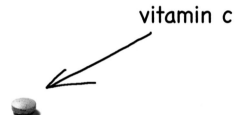

vitamin c not only prevents scurvy, it's an essential nutrient with a variety of functions in the body.

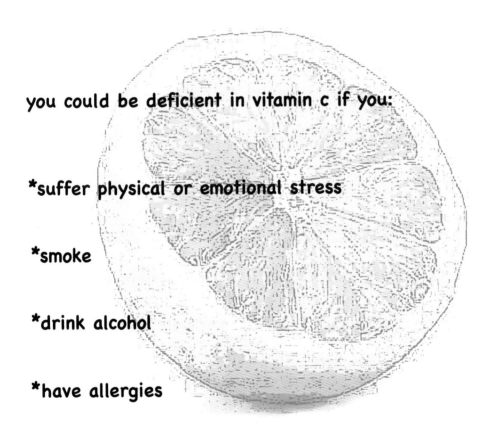

you could be deficient in vitamin c if you:

*suffer physical or emotional stress

*smoke

*drink alcohol

*have allergies

*take antibiotics, cortisone or pain killers

*are exposed to toxic xhemicals and pollution

Powers Versus Creativity

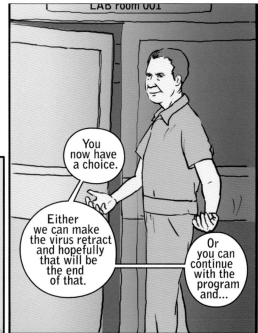

LAB room 001

You now have a choice.

Either we can make the virus retract and hopefully that will be the end of that.

Or you can continue with the program and...

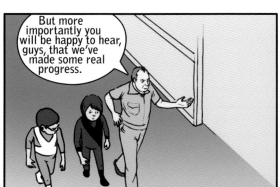

But more importantly you will be happy to hear, guys, that we've made some real progress.

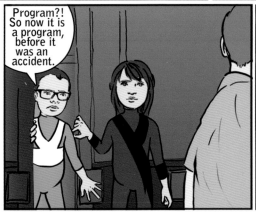

Program?! So now it is a program, before it was an accident.

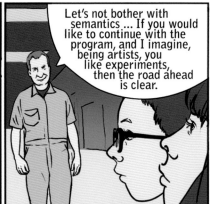

Let's not bother with semantics ... If you would like to continue with the program, and I imagine, being artists, you like experiments, then the road ahead is clear.

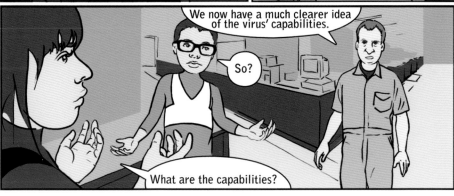

We now have a much clearer idea of the virus' capabilities.

So?

What are the capabilities?

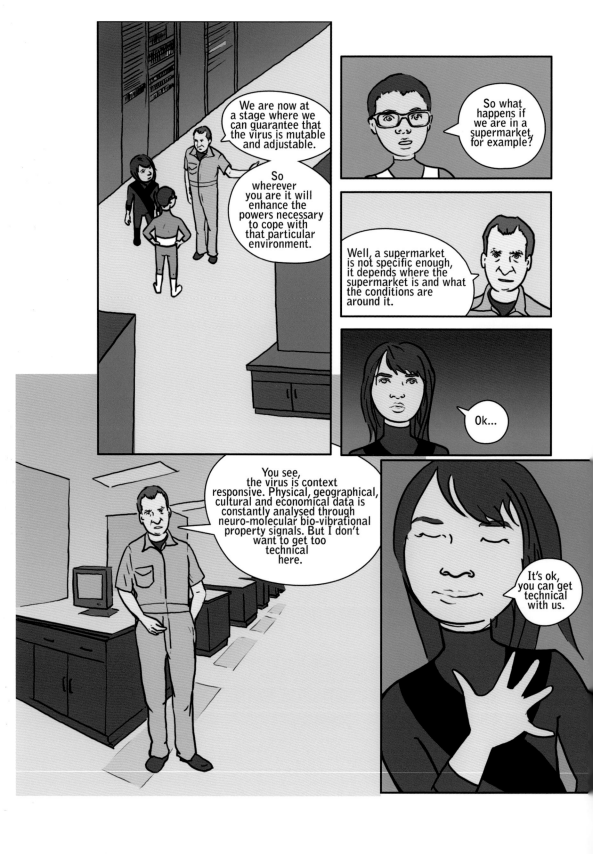

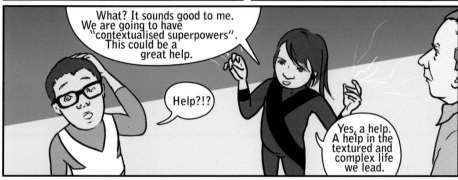

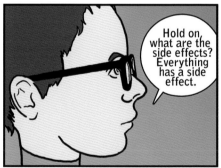

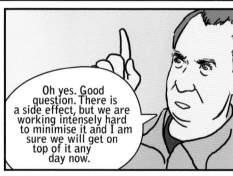

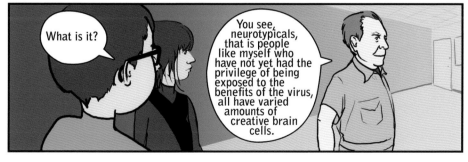

The higher the proportion of the glial cells to the neurons is, the more creative or 'connected' an individual is. You see, creativity, variability and connectivity are closely related.

Artists, of course, have a high level of glial cells and are hence more creative, connected and variable.

Well, in theory maybe.

So, what's with these glial cells?

Yes, back to our virus. Our virus has to draw its energy from somewhere, and at this stage of its development it comes from the glial cells.

Oh, I get it.

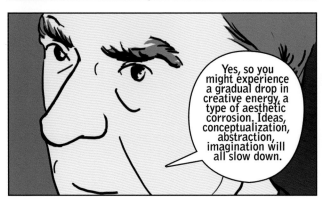

Yes, so you might experience a gradual drop in creative energy, a type of aesthetic corrosion. Ideas, conceptualization, abstraction, imagination will all slow down.

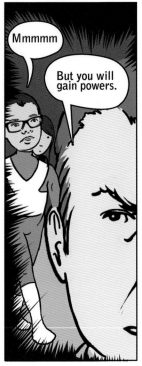

Mmmmm

But you will gain powers.

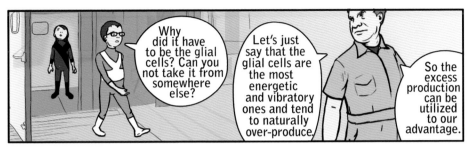

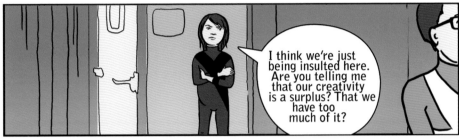

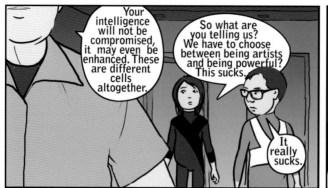

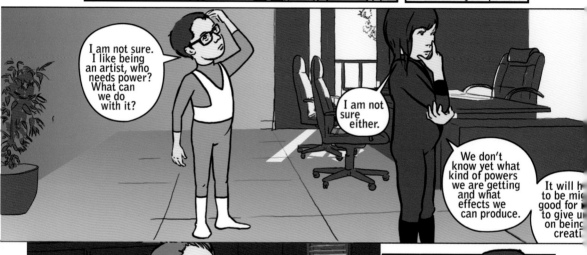
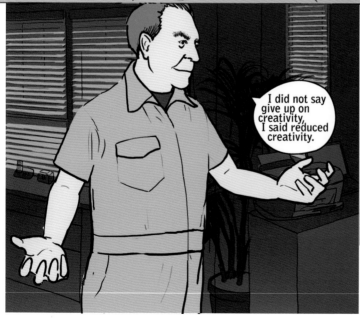

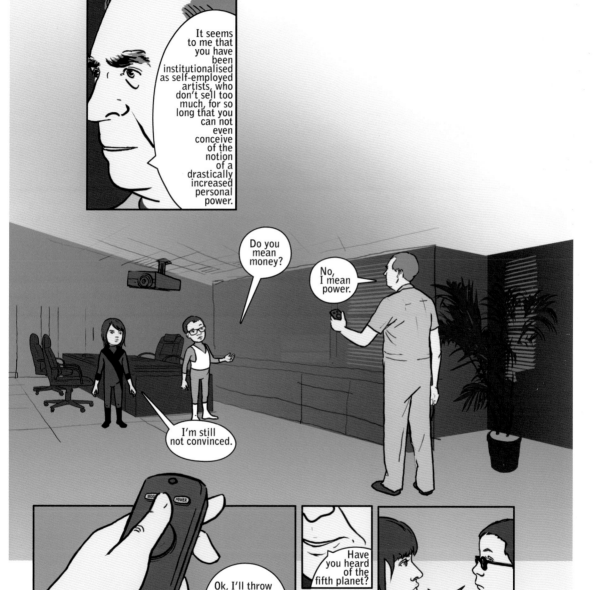

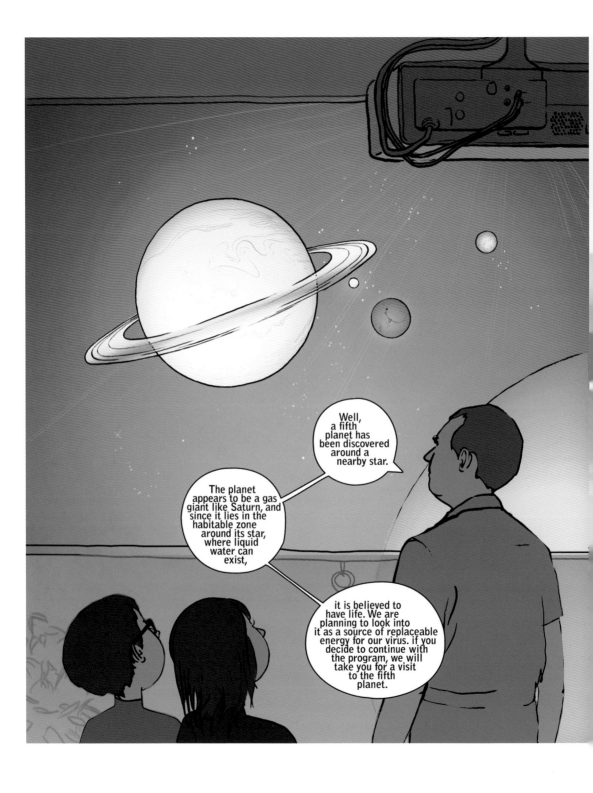

Colonialism

Imperial War Museum, London

Imperial Trivia

1. Towards the end of the nineteenth century, British colonial officials were advocating the idea of a Jewish colonization of Palestine as part of the construction of which kind of order in the region?

☐ social order ☐ agricultural order
☐ festive order ☐ permanent imperial order

2. As early as 1900, Theodor Herzl, founder of Political Zionism, regarded which empire as the Archimedean point at which the lever to erect a Jewish homeland in Palestine could be applied?

☐ Mongol Empire ☐ British Empire
☐ Persian Empire ☐ Hittite Empire

3. In 1918, the War Office of which imperial power issued the following statement:

The creation of a buffer Jewish state in Palestine, though this state will be weak in itself, is strategically desirable for Britain.

☐ Philippines ☐ Finland
☐ Maldives ☐ Britain

4. Which famous statesman is responsible for the following statement:

Left to themselves, the Arabs of Palestine would not in a thousand years have taken effective steps towards the irrigation and electrification of Palestine. They would have been quite content to dwell – a handful of philosophic people – in wasted sun-drenched plains, letting the waters of the Jordan flow unbridled and unharnessed into the Dead Sea.

☐ Chillstone Worthspill ☐ Alisdair von Undergarment
☐ Clinton Wursthill ☐ Winston Churchill

5. In late 1930s, a Christian intelligence officer of which imperial army was responsible for the training of the Jewish "night squads" carrying out deadly missions against Palestinians?thereby not only assisting the Jewish militias in their battle for Palestine, but also establishing the Israel Defence Forces' core military doctrines still in effect in Palestine today.

☐ The Roman army ☐ The Ottoman army
☐ The British army ☐ The Byzantine army

6. Although still responsible for the overall security in the city, the authorities of which faltering imperial power did all but nothing to prevent the dramatic de-Arabization of Haifa in April 1948 during which scores of panic-stricken Palestinian civilians drowned trying to flee the city in overcrowded boats?

☐ England ☐ Britain
☐ Great Britain ☐ United Kingdom

"CONFLICT" DOMINOS

What Shall We Do?

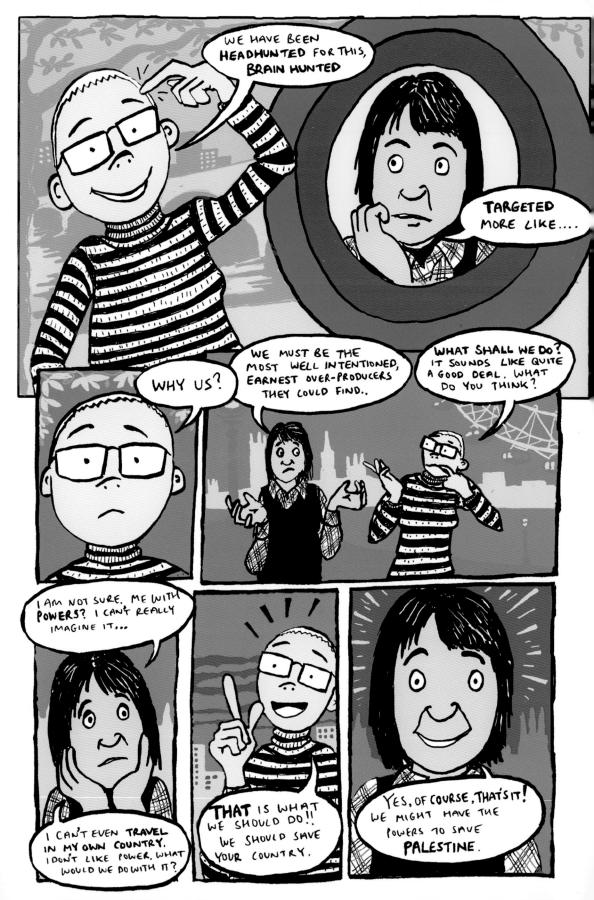

Orientalism

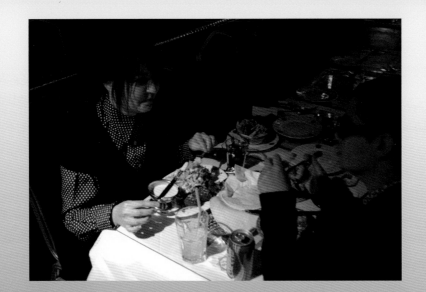

Edgware Road, London

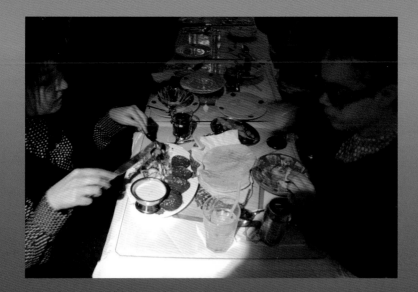

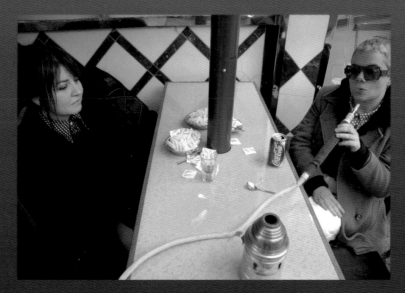

Edgware Road, London

Arabian Nights original lyrics

Oh, I come from a land

From a faraway place

Where the caravan camels roam

Where they cut off your ear

If they don't like your face

It's Barbaric, but hey, it's home

From Disney's *Aladdin, 1992*

Original photograph: Oreet's grandmother and her sister, Jerusalem, 1920s, unknown photographer

Why do Persians fill their houses with carpets? In case a guest drops a coin, the sound will not be heard.

Why do Moroccans have so many children? They keep trying for a successful one.

A Kurd sits in a taxi, the taxi goes fast down a big hill, the Kurd shouts: "Stop!" The driver says: "I can't!" The Kurd replies: "Not the car, the meter!"

What is a Gruzini (from Georgia) who has been beaten up? A blue square.

What is the difference between an Iraqi and a film camera? Film can be developed.

Why does a Gruzini go to the operation room with one sock? He will be anaesthetised with the other one.

What is an Iraqi holocaust survivor? One who divorced his wife.

A Kurd sits and watches ice cubes for ages. His friend is getting impatient and asks him: "What are you looking at?" The Kurd replies: "I simply can't see where the leak is coming from."

Why does an Iraqi take his newly wedded wife to the Wailing Wall? So she will learn to talk to a wall.

A Moroccan, a Persian, and an Indian sit on a plane. The air hostess comes to them and asks: "Aren't you sick of this joke?"

Why does a Mizrahi go to the bank with a blanket? To cover his debt.

A Kurd and a Moroccan are looking at the moon. The Kurd says: "I've heard the Americans sent a spaceship to the moon, let's see if we can spot it." The Moroccan replies: "Don't be daft, it is not our moon, it's the moon abroad!"

A Gruzini goes to the beach in Tel Aviv where he sees a bottle and opens it. Out comes a genie. The genie grants the Gruzini one wish. The Gruzini says: "Build me a bridge here to New York." The genie says: "What for? Ask for something more possible, more useful." The Gruzini says: "Ok, make my son a Doctor, then." The genie says: "Ok, I will build you that bridge . . ."

Text about Jokes

In Israel, there is a genre of jokes depicting Oriental (Mizrahi) Jews as tight, naive, stupid, incompetent, underachievers, primitive, backwards – when it comes to gender relations in marriage life, for example – as well as unkempt and childlike.

There are also genres of jokes about orthodox Jews, Polish Jews, and Yekkes – a mildly derogatory term for German Jews – as well as sexist jokes, jokes about people from other countries, religions, and so forth. And then there are, of course, jokes specifically about Arabs or Palestinians.

The Oriental Jewish jokes are particularly poignant in reflecting a Jewish Israeli society that has always been dominated by Ashkenazi Jews (with extended histories in Europe, Mediterranean countries aside) and where the social, economic, and cultural implications of that fact have rendered Oriental Jews, in general, less privileged. In recent years, the very idea of a Mizrahi protest against the situation has become a subject for jokes in itself – with Mizrahi Jews now also portrayed as constant complainers or moaners.

Recently, the politically correct call to rethink these derogatory ideas has partly resulted in jokes starting with: "One day, a no-matter-from-what-community-of-origin Jew . . ." However, this often makes the joke even funnier, as the unmentioned Eastern community of origin is already known or implicated by the very type of joke. As with most postmodern cultural trajectories located in identity politics, those same jokes are used effectively in the arts and in popular culture as a direct way to highlight and combat prejudices against non-Western Jews and their consequences.

Quote
Most of the Mizrachim immigrated to Israel beginning in the 1950s, by which time the Ashkenazim had already solidified their control over the institutions of the state and the economy, including the bureaucracy and the Israeli Defense Forces (IDF). Upon arrival, most Mizrachim were subjected to indignities by Ashkenazi officials – including being sprayed with DDT before being allowed into the country – and found themselves on the economic, political, and social margins of Israeli life.

Kamrava, Mehran, *The Modern Middle East: A Political History Since the First World War.* Berkeley: University of California Press, 2005, pp. 219–220.

Quote
The term Mizrahi came to be widely used by so-called Mizrahi activists in the early 1990s, and since then has become an accepted designation.
Many "Mizrahi", in translation "Oriental" Jews today reject this (or any) umbrella and simplistic description and prefer to identify themselves by their particular country of origin, or that of their immediate ancestors, e.g. "Iranian/Persian Jew", "Iraqi Jew", "Tunisian Jew", etc.
Wikipedia

Generic Anti-Arab Joke

What's one Arab on the Moon?

A problem.

10 Arabs on the Moon?

A slightly bigger problem.

100 Arabs on the Moon?

A large problem.

1,000 Arabs on the Moon?

A huge problem.

1,000,000 Arabs on the Moon?

A massive problem.

All the Arabs on the Moon?

Problem solved!

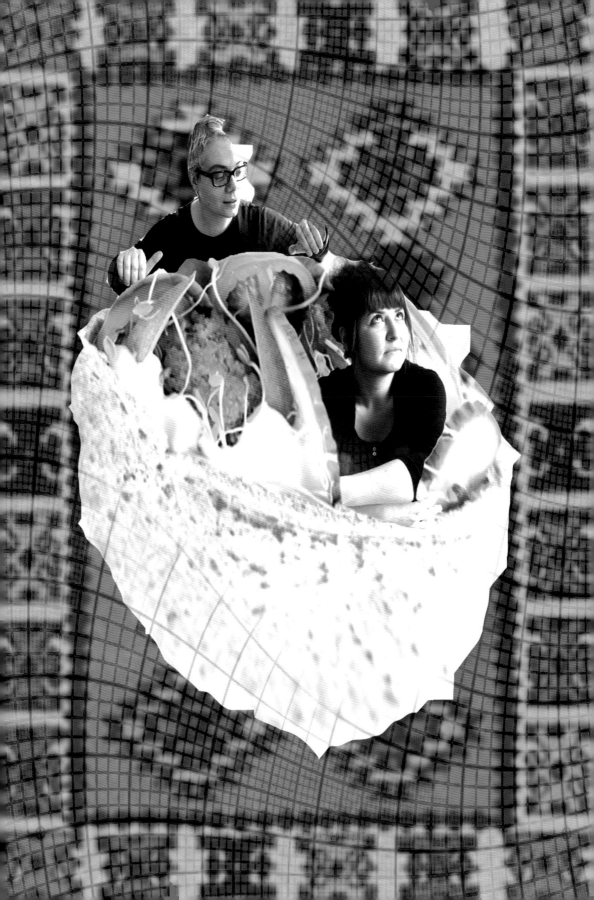

Your Own Cut Out Palestinian Doll with Authentic Palestinian Gear

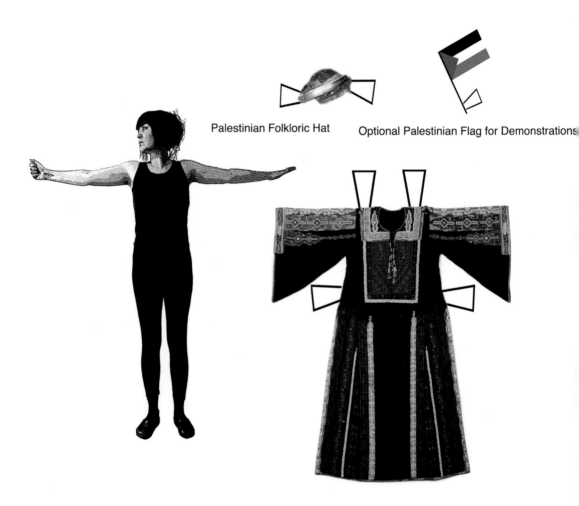

Palestinian Folkloric Hat

Optional Palestinian Flag for Demonstrations

Palestinian Folkloric Dress

Your Own Cut Out Danish Postman with Authentic Danish Gear

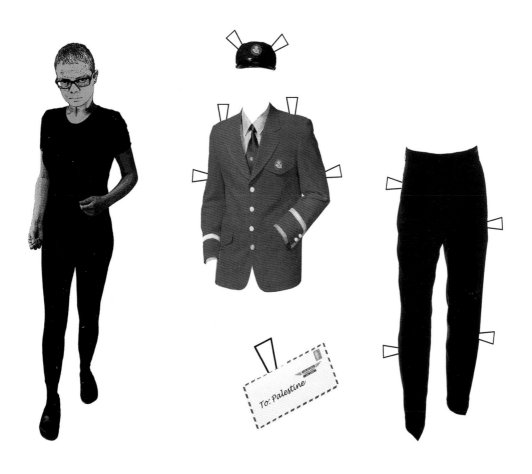

Palestine,
Here We Come

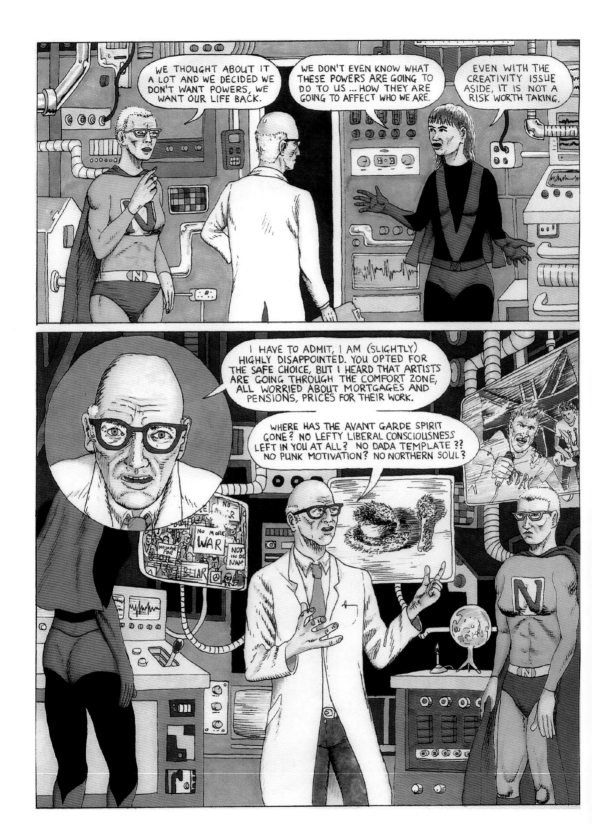

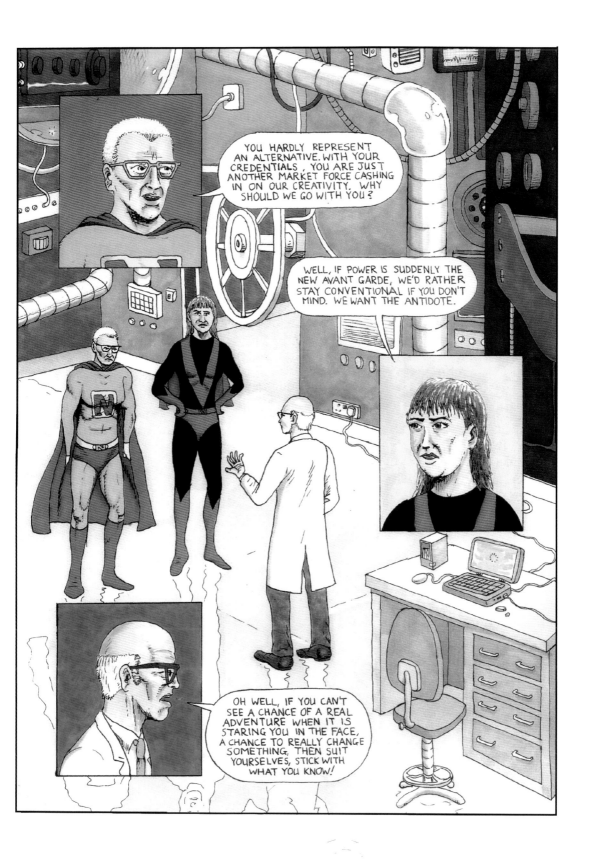

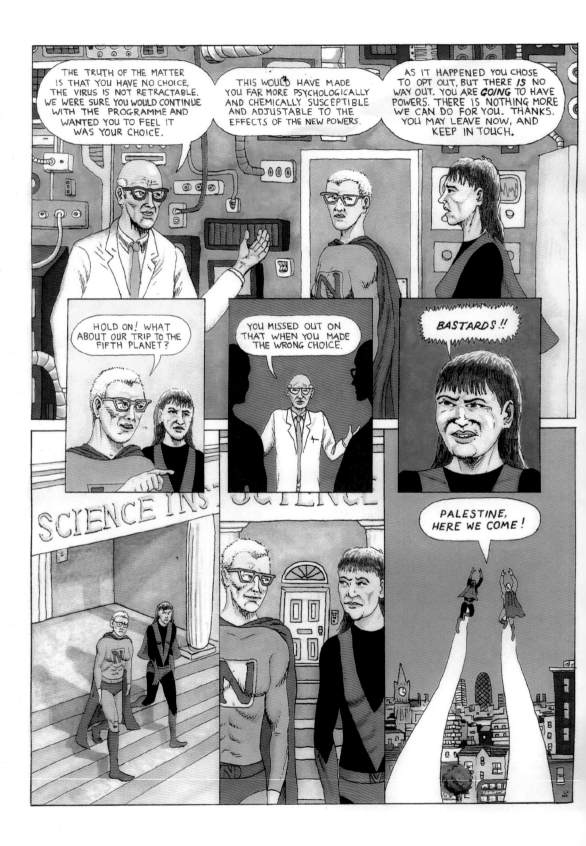

The Peace Process

Popular Middle Eastern Euphemisms and Misnomers

Wherever there is anything at stake, terminology is never innocent. Shaping, justifying, and advancing political agendas, national identity, and favourable versions of history has a lot to do with chiseling the appropriate concepts and easing them into the mainstream. Language is a highly effective mode of seduction. Whoever successfully coins her own terms and manages to slide them into a wider dialogue stands a better chance of having her own political agenda generally accepted – without having to argue for it.

In the context of the Middle East, terminology is rarely neutral. It is often systematically designed to promote political agendas by altering, distorting, camouflaging or simply muffling facts. The following is a list of words and concepts commonly used by Israel – and, in many cases, accepted by the international community and media – to mask, conceal, distort and blur the nature, reality and illegitimacy of the occupation.

Middle East Conflict

Security barrier	Militants
Reunified Jerusalem	Disputed territories
Israel Defense Forces	Moderate physical pressure
Anti-Semitism	Israeli War of Independence
No partners for peace	Israeli Arabs
Hamastan	Jerusalem suburbs
For security reasons	Religious conflict
Terrorists	Israel as the only democracy in the Middle East
Judea and Samaria	Jewish State
Retaliation	Disproportionate force
Self-defense	Gaza Disengagement
Precision bombing	The Israeli Peace Camp
Restraint	
Two narratives	

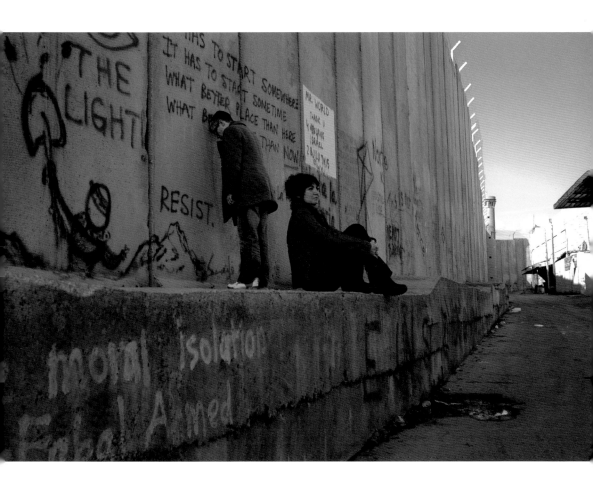

Segregation Wall

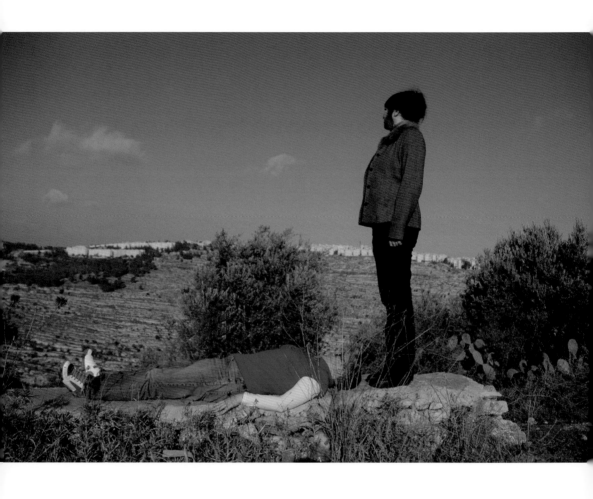

Settlements

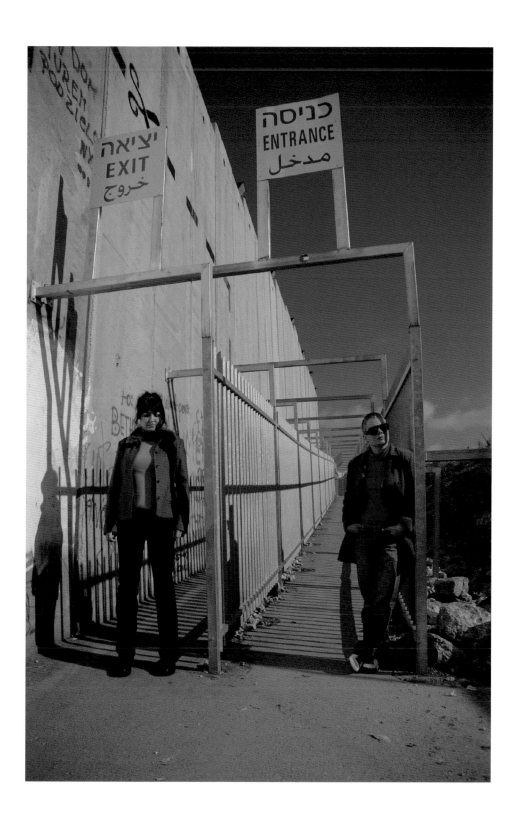

Bethlehem Checkpoint

Dead Sea Mud

Molotov Cocktail

Uzi

Olive Branch

Olive Soap

Holy Water

Slingshot

A Stone

Falafel

"CONFLICT" PARAPHERNALIA

MOST-TRAUMATIC CHESS DISORDER

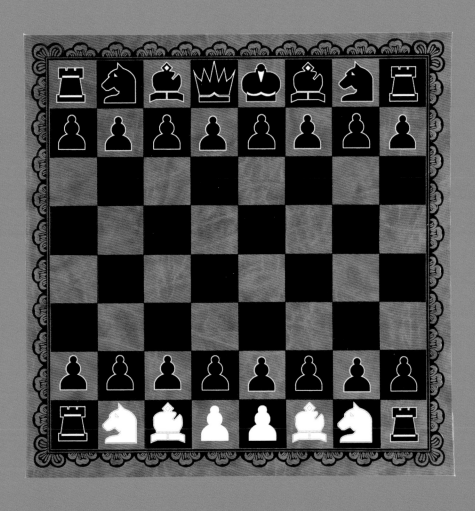

60 **Finish**	**Right of Return** **59**	**58**	**57**	**56**
The Wall **41**	**42**	**43**	**44**	**45**
40	**39**	**38**	**37** **Oslo Treaty**	**36**
21	**22**	**23**	**24**	**25**
20	**19**	**18**	**No Permit** **17**	**16**
1 **Start**	**2** **1948**	**3**	**4**	**5**

PART 2

INTERGALACTIC PALESTINE

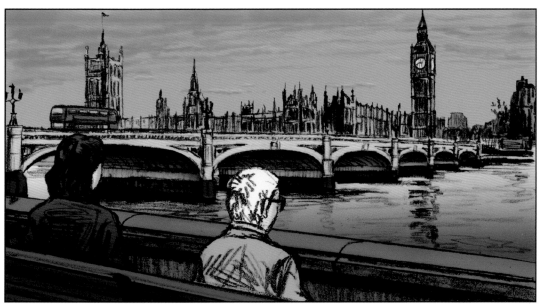

SO, A REAL WRITER TAKING OVER, HUH? THE PROSPECT OF SURRENDERING CONTROL MAKES ME A BIT NERVOUS. HOW ABOUT YOU?

YEAH, I KNOW. BUT IN A WAY THIS WHOLE COLLABORATION IS AN EXERCISE IN MUFFLING OUR INNER CONTROL FREAKS. WE WOULDN'T HAVE COME THIS FAR WITHOUT SUSPENDING OUR INDIVIDUAL EGOS ONCE IN A WHILE. MAYBE NOW'S THE TIME TO LEAVE OUR BABY IN THE HANDS OF SOMEBODY ELSE.

I GUESS. AND IF IT BLOWS UP IN OUR FACES WE CAN ALWAYS BLAME THE WRITER, HA HA. ALRIGHT, LET'S GIVE HIM THE GO-AHEAD, BUCKLE UP AND PREPARE FOR AN UNPREDICTABLE JOURNEY.

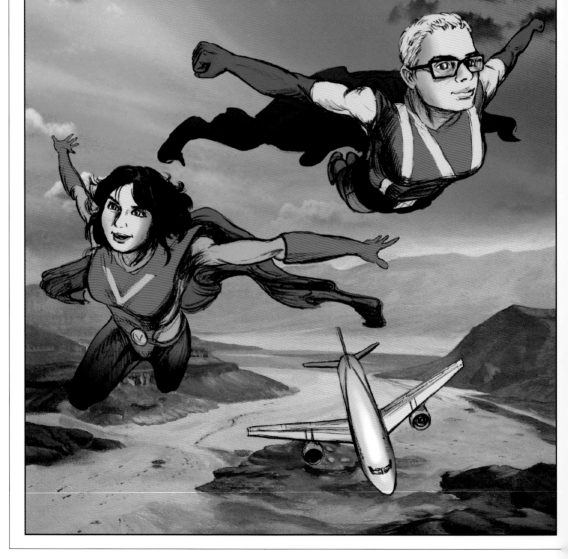

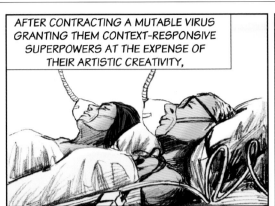

AFTER CONTRACTING A MUTABLE VIRUS GRANTING THEM CONTEXT-RESPONSIVE SUPERPOWERS AT THE EXPENSE OF THEIR ARTISTIC CREATIVITY,

EX-ARTISTS NONEL AND VOVEL DECIDE TO PUT THEIR NEW IDENTITIES TO THE TEST IN OCCUPIED PALESTINE.

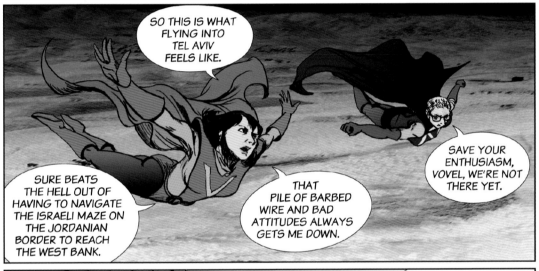

SO THIS IS WHAT FLYING INTO TEL AVIV FEELS LIKE.

SAVE YOUR ENTHUSIASM, VOVEL, WE'RE NOT THERE YET.

SURE BEATS THE HELL OUT OF HAVING TO NAVIGATE THE ISRAELI MAZE ON THE JORDANIAN BORDER TO REACH THE WEST BANK.

THAT PILE OF BARBED WIRE AND BAD ATTITUDES ALWAYS GETS ME DOWN.

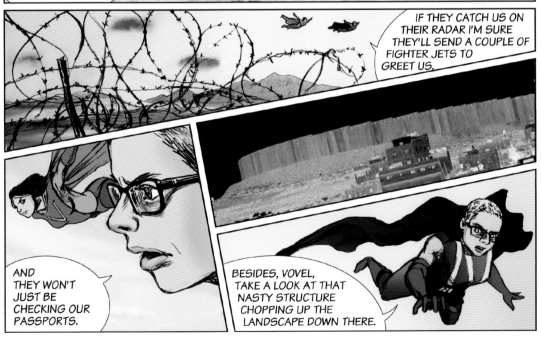

IF THEY CATCH US ON THEIR RADAR I'M SURE THEY'LL SEND A COUPLE OF FIGHTER JETS TO GREET US.

AND THEY WON'T JUST BE CHECKING OUR PASSPORTS.

BESIDES, VOVEL, TAKE A LOOK AT THAT NASTY STRUCTURE CHOPPING UP THE LANDSCAPE DOWN THERE.

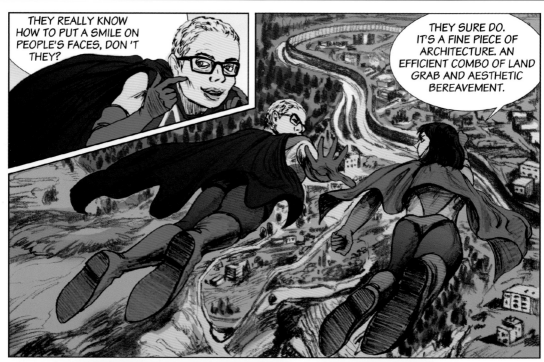

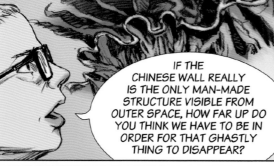

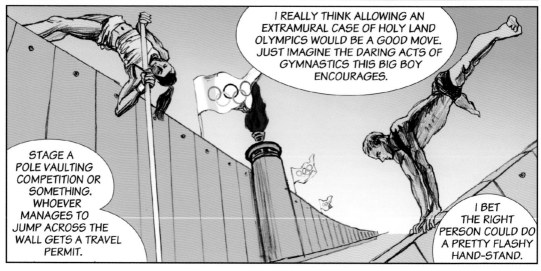

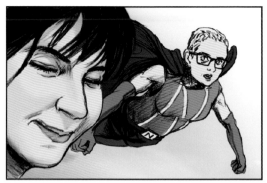

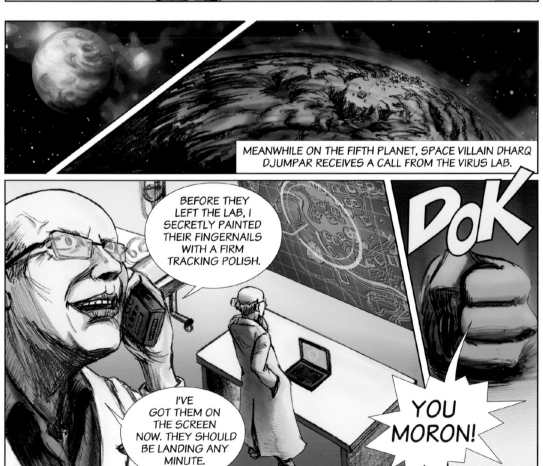

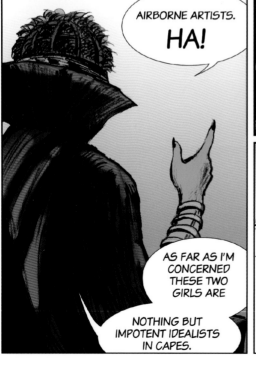
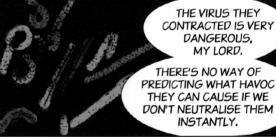
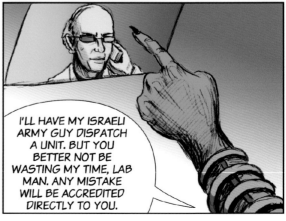

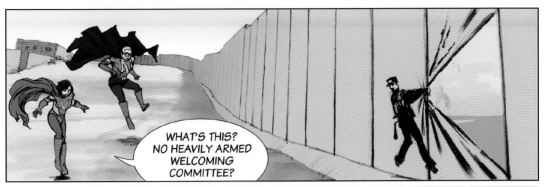

WHAT'S THIS? NO HEAVILY ARMED WELCOMING COMMITTEE?

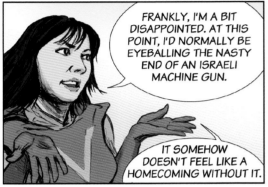

FRANKLY, I'M A BIT DISAPPOINTED. AT THIS POINT, I'D NORMALLY BE EYEBALLING THE NASTY END OF AN ISRAELI MACHINE GUN.

IT SOMEHOW DOESN'T FEEL LIKE A HOMECOMING WITHOUT IT.

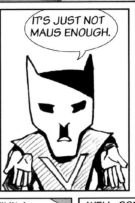

IT'S JUST NOT MAUS ENOUGH.

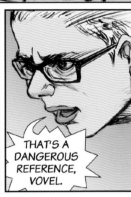

THAT'S A DANGEROUS REFERENCE, VOVEL.

WHY? YOU THINK A PALESTINIAN REFERENCING SPIEGELMAN COULD SOMEHOW SPARK ACCUSATIONS OF ANTI-SEMITISM? I'M SURE YOU ARE RIGHT. BUT IF YOU ASK ME, THAT'S A MINEFIELD NOBODY CAN NAVIGATE SAFELY ANYWAY. SO WHY EVEN TRY?

WELL, CONSIDERING THE NATURE OF OUR PROJECT, MAYBE THEY BOTH DESERVE ONE.

I WAS ACTUALLY MORE CONCERNED WITH THE POTENTIAL AVALANCHE OF TRIBUTES. IF JOE SACCO EVER HEARS SPIEGELMAN GOT A MENTION, HE'S GONNA WANT ONE, TOO.

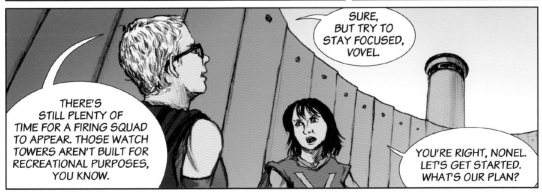

SURE, BUT TRY TO STAY FOCUSED, VOVEL.

THERE'S STILL PLENTY OF TIME FOR A FIRING SQUAD TO APPEAR. THOSE WATCH TOWERS AREN'T BUILT FOR RECREATIONAL PURPOSES, YOU KNOW.

YOU'RE RIGHT, NONEL. LET'S GET STARTED. WHAT'S OUR PLAN?

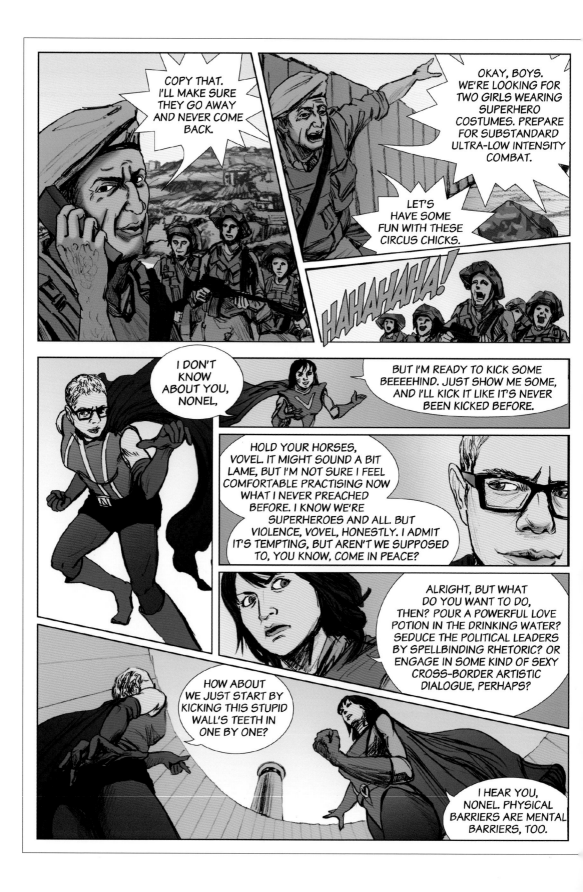

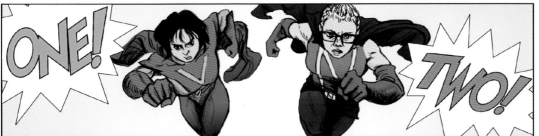

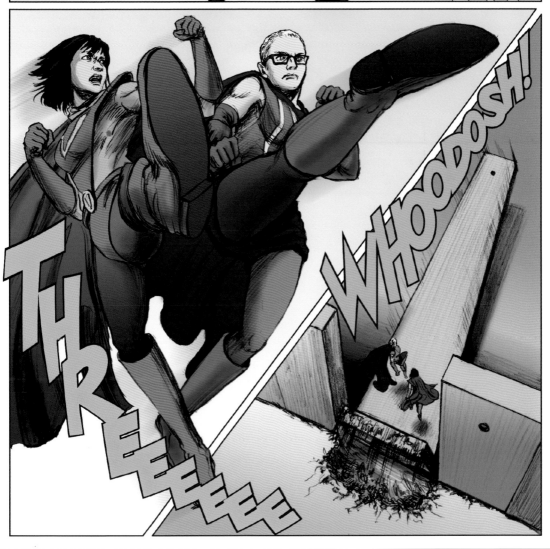

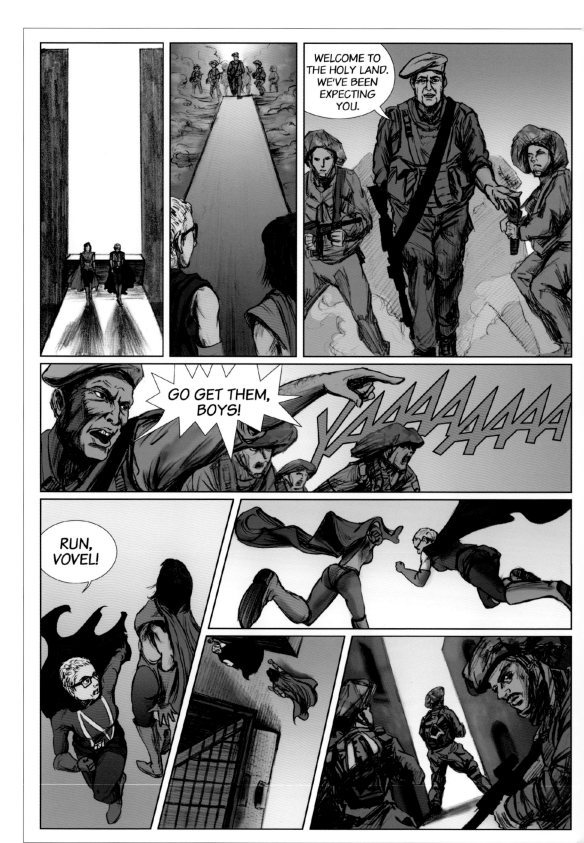

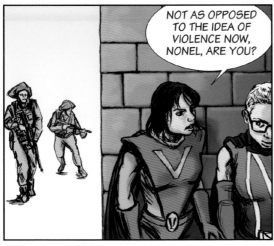

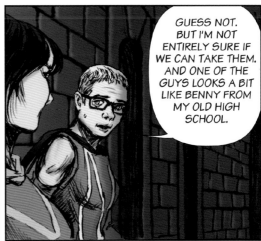

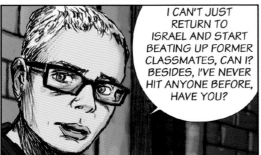

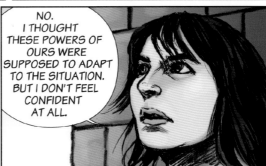

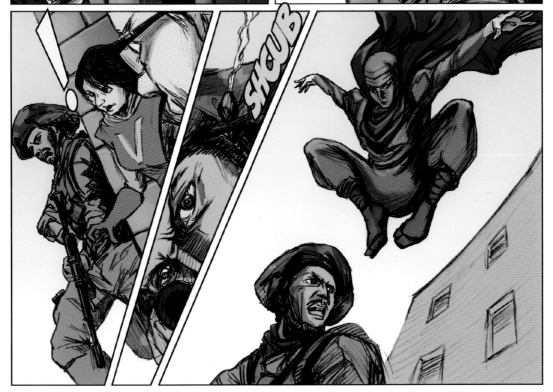

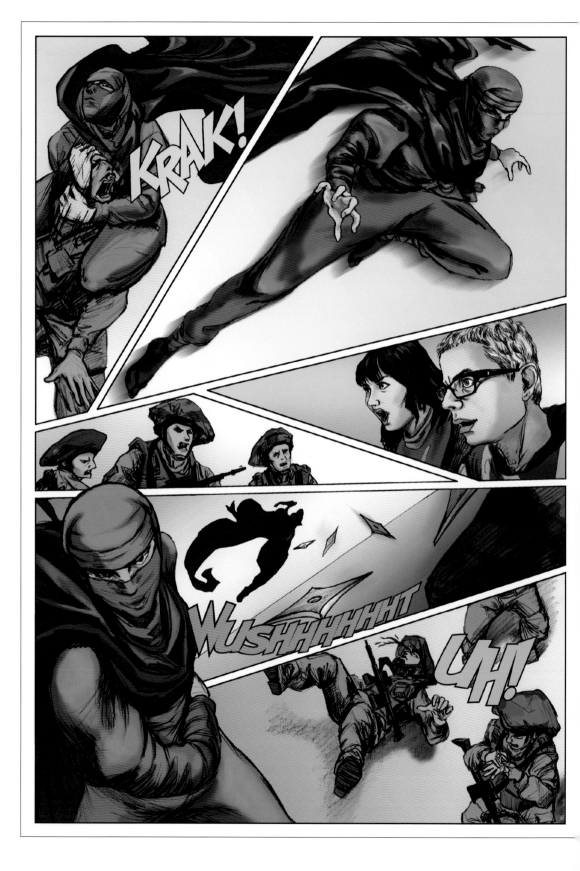

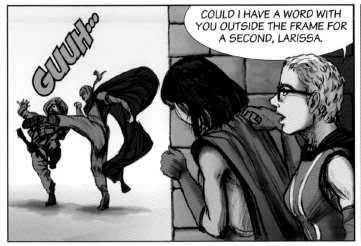

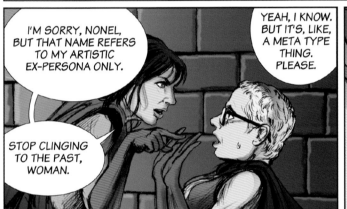

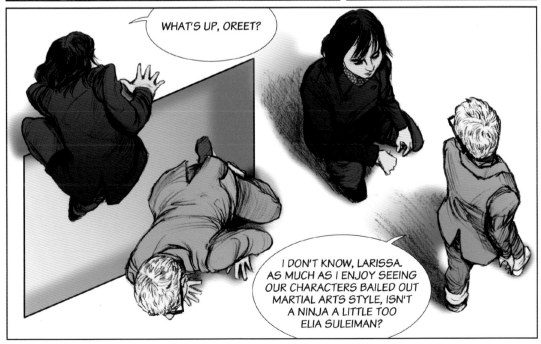

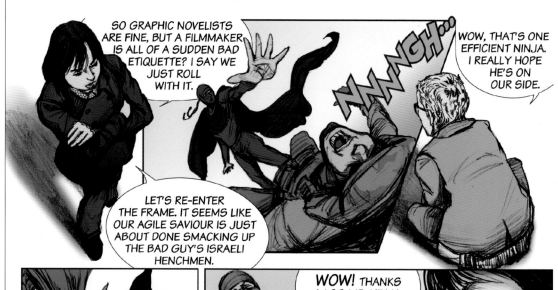

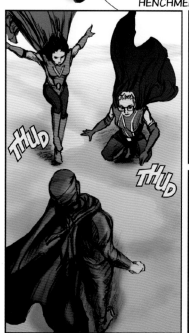

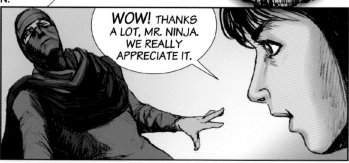

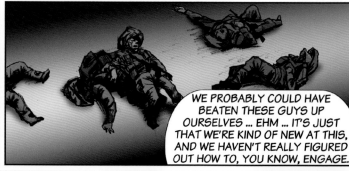

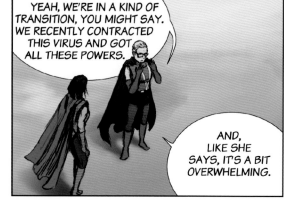

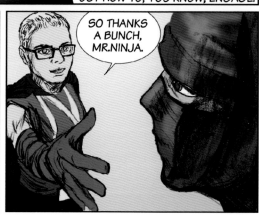

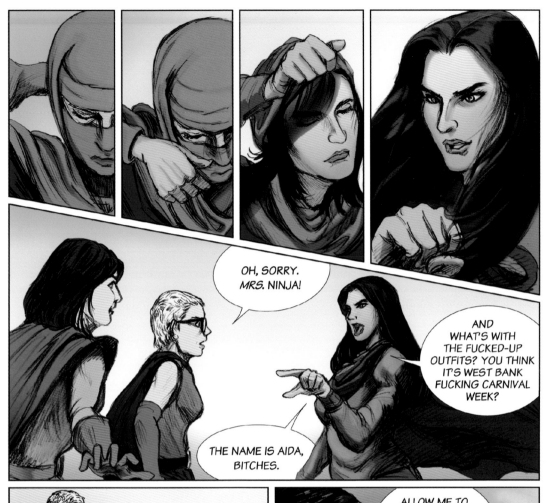

OH, SORRY. MRS. NINJA!

THE NAME IS AIDA, BITCHES.

AND WHAT'S WITH THE FUCKED-UP OUTFITS? YOU THINK IT'S WEST BANK FUCKING CARNIVAL WEEK?

WELL... EHM... I GUESS THEY'RE PRETTY STANDARD SUPERHERO COSTUMES. TIGHT AND GLOSSY AND ALL.

YEAH, PROBABLY SUPPOSED TO MAKE US FLY FASTER, YOU KNOW, WHENEVER WE FLY. IN FACT, WE JUST FLEW IN. WE'RE ON A MISSION TO END THE OCCUPATION.

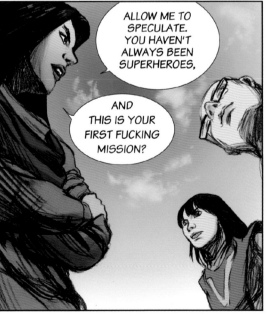

ALLOW ME TO SPECULATE. YOU HAVEN'T ALWAYS BEEN SUPERHEROES,

AND THIS IS YOUR FIRST FUCKING MISSION?

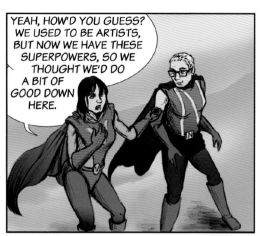

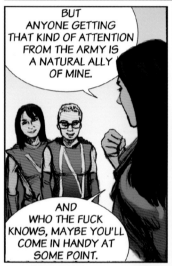

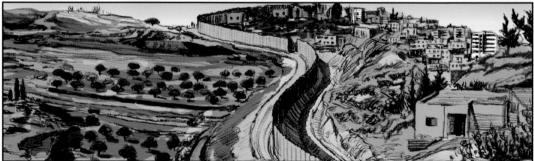

MEANWHILE ON THE FIFTH PLANET.

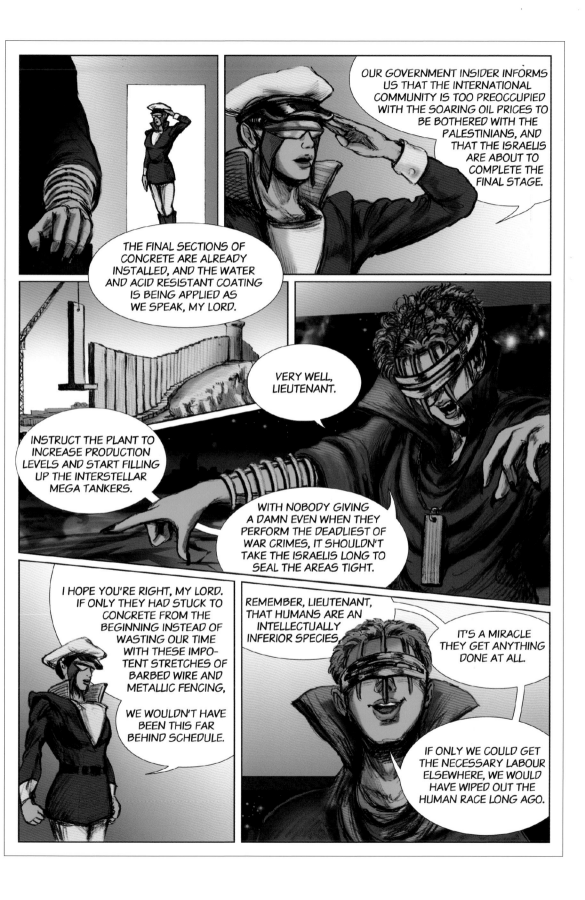

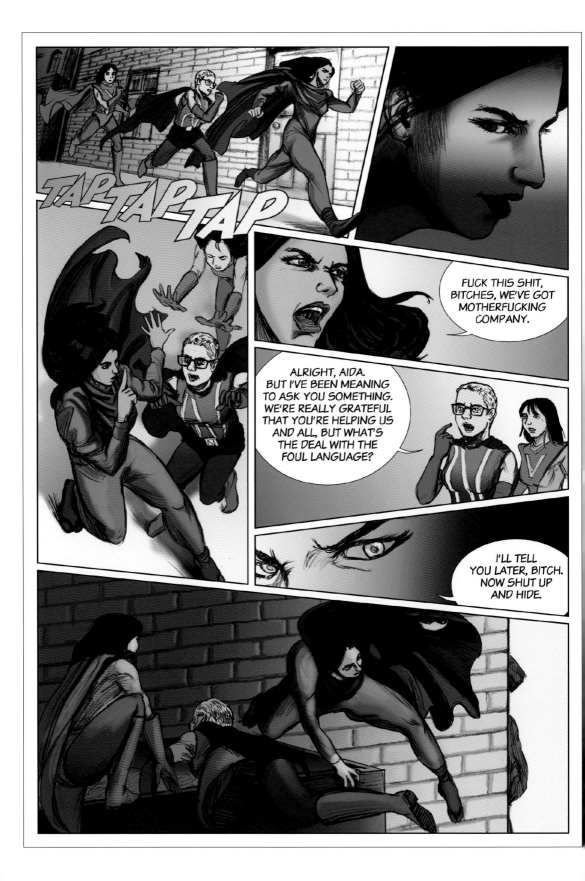

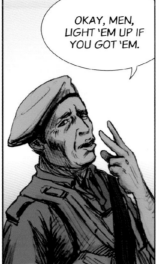

OKAY, MEN, LIGHT 'EM UP IF YOU GOT 'EM.

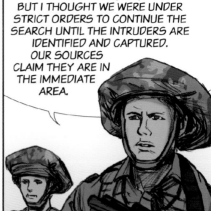

EXCUSE ME, SIR, BUT I THOUGHT WE WERE UNDER STRICT ORDERS TO CONTINUE THE SEARCH UNTIL THE INTRUDERS ARE IDENTIFIED AND CAPTURED. OUR SOURCES CLAIM THEY ARE IN THE IMMEDIATE AREA.

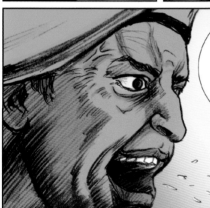

WHAT'S THAT, GOODY TWO-SHOES? DOES MY NICOTINE BREAK CONFLICT WITH YOUR SENSE OF DUTY? YOU'RE MORE THAN WELCOME TO CONTINUE PLAYING COPS AND ROBBERS WHILE THE REST OF US WAIT HERE.

BUT, SIR, THE THREAT IS CLASSIFIED AS IMMINENT. OUR NATIONAL SECURITY IS AT STAKE.

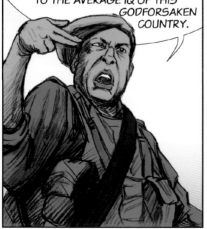

YOU BELIEVE EVERYTHING THEY TELL YOU IN KINDERGARTEN, SOLDIER? WE'RE LOOKING FOR A COUPLE OF CLOWNS IN COLOURFUL LATEX SUITS. IT'S A THREAT, ALRIGHT, BUT ONLY TO THE AVERAGE IQ OF THIS GODFORSAKEN COUNTRY.

FUCK ME! THEY REALLY ARE LOOKING FOR YOU BITCHES.

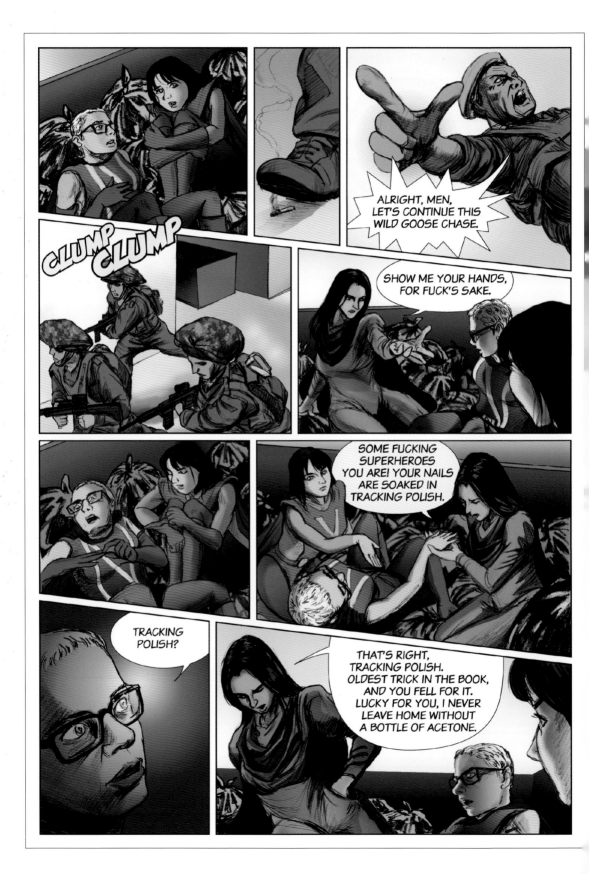

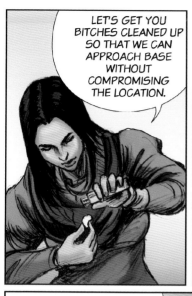

LET'S GET YOU BITCHES CLEANED UP SO THAT WE CAN APPROACH BASE WITHOUT COMPROMISING THE LOCATION.

BASE? YOU MEAN YOU'RE NOT THE ONLY NINJA OPERATING IN THE AREA?

HELL NO, BITCH!

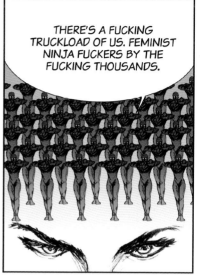

THERE'S A FUCKING TRUCKLOAD OF US. FEMINIST NINJA FUCKERS BY THE FUCKING THOUSANDS.

SORRY TO RAISE THE ISSUE AGAIN, AIDA, BUT I CAN'T HELP WONDERING HOW YOUR NINJA SISTERS RESPOND TO THIS IMMENSELY FOUL LANGUAGE OF YOURS?

CONSIDERING OUR SITUATION, DO YOU REALLY THINK THEY GIVE A RAT'S ASS?

A FUCK-YOU FLY?

BESIDES, THE SWEARING IS NOT MY FAULT. I GOT STUNG BY A FUCK-YOU FLY.

YEAH, A FUCK-YOU FLY. NASTY LITTLE BASTARDS DESIGNED TO DISSOCIATE US INTERNALLY. YOU GET STUNG BY THESE FUCKERS, AND THE ONLY SYMPTOM IS A FOUL MOUTH.

THE RATIONALE BEING THAT A FOUL MOUTH IS SUFFICIENT GROUNDS FOR OSTRACISING PEOPLE?

EXACTLY, I GUESS THEY THINK WE'RE SO FUCKING RELIGIOUS AND UPTIGHT THAT THAT'S ALL IT TAKES. WELL, THE JOKE'S ON THEM.

I CAN'T BELIEVE THAT A SMALL FLY IS RESPONSIBLE FOR YOUR FILTHY TONGUE.

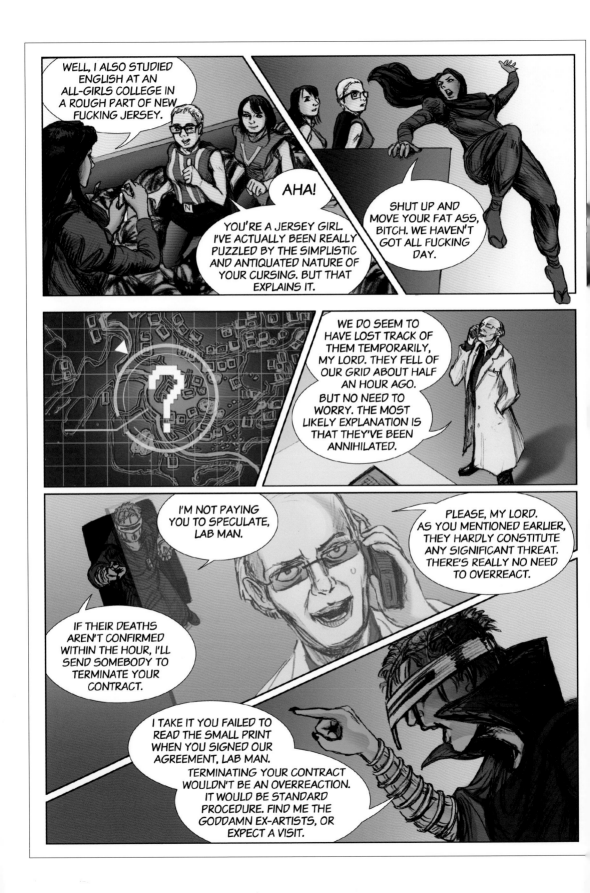

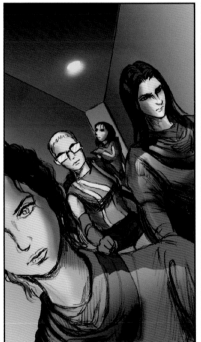

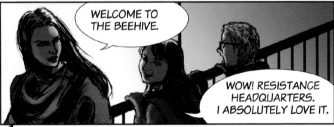

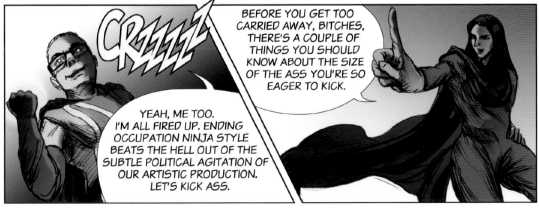

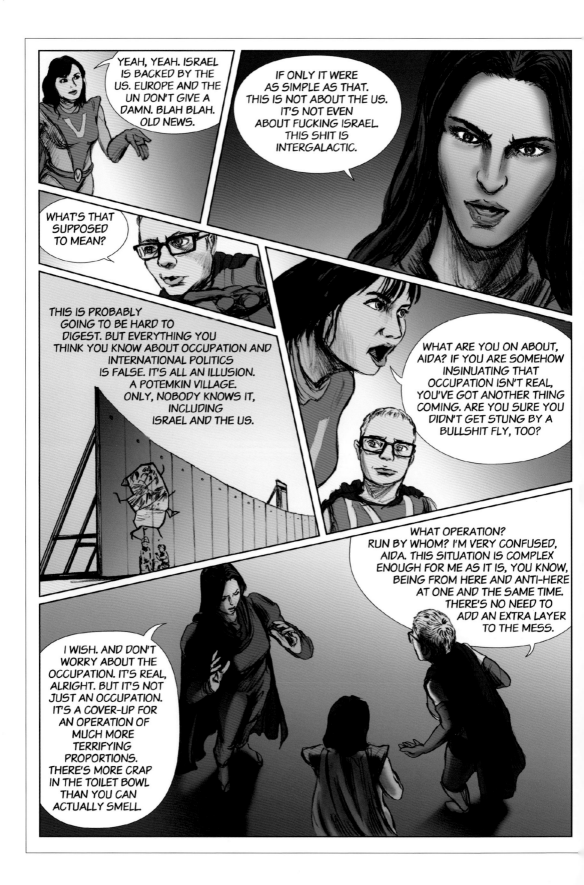

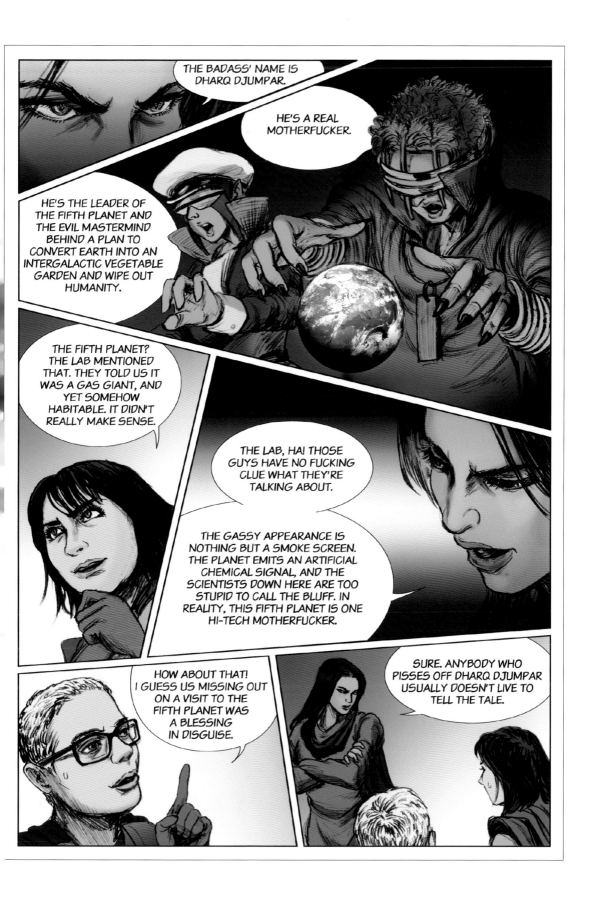

BACK AT RESISTANCE HEADQUARTERS, NONEL AND VOVEL ARE STILL TRYING TO COMPREHEND THE MAGNITUDE OF DHARQ DJUMPAR'S EVIL SCHEME.

SO LET ME GET THIS STRAIGHT. EVEN THOUGH THE OCCUPATION IS REAL, AND THE ISRAELIS ARE DE FACTO MANAGING IT,

AMERICAN SUPPORT FOR THE NEO-COLONIAL LEGOLAND THE ISRAELIS ARE DEVELOPING IS NOT THE REAL REASON FOR PALESTINIANS BEING ROYALLY SCREWED. RIGHT?

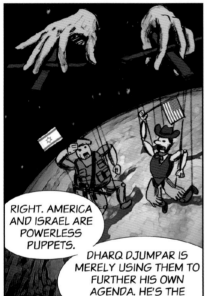

AND WHAT DOES THAT MAKE PALESTINE?

RIGHT. AMERICA AND ISRAEL ARE POWERLESS PUPPETS.

DHARQ DJUMPAR IS MERELY USING THEM TO FURTHER HIS OWN AGENDA. HE'S THE PUPPET MASTER.

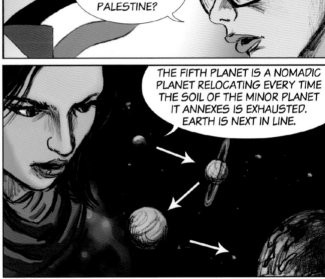

THE FIFTH PLANET IS A NOMADIC PLANET RELOCATING EVERY TIME THE SOIL OF THE MINOR PLANET IT ANNEXES IS EXHAUSTED. EARTH IS NEXT IN LINE.

GROWING WHATEVER IT IS THEY EAT UP THERE TAKES BILLIONS AND BILLIONS OF GALLONS OF A HIGH-STRUNG LIQUID FERTILISER.

THAT DOESN'T SOUND TOO GOOD. AS I SEE IT, THIS DHARQ DJUMPAR'S GOT TO GO.

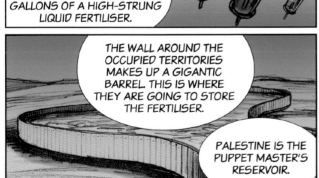

THE WALL AROUND THE OCCUPIED TERRITORIES MAKES UP A GIGANTIC BARREL. THIS IS WHERE THEY ARE GOING TO STORE THE FERTILISER.

PALESTINE IS THE PUPPET MASTER'S RESERVOIR.

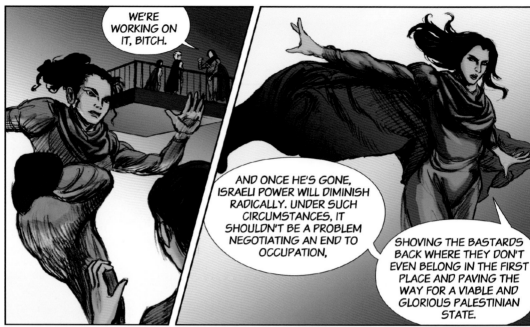

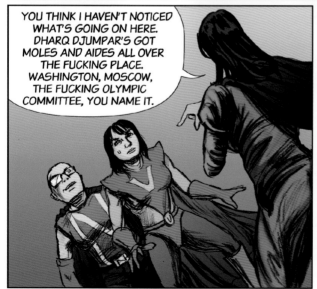

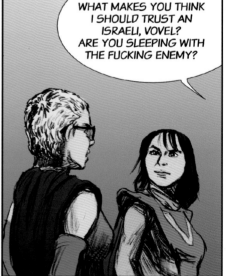

LIKE WHAT? LIKE SOME KIND OF SUBTLE COMMENT ON THE INABILITY OF POLITICAL ARTISTS, EX- OR NOT, TO BRING ABOUT REAL CHANGE? HE COULDN'T POSSIBLY BE THAT CHEEKY, THIS WRITER.

SO WHAT DO YOU THINK, OREET? HAPPY WITH THE STORY SO FAR?

YEAH, SURE. I JUST HOPE WE GET THE CHANCE TO USE THESE SUPPOSED SUPERPOWERS OF OURS.

SO FAR, I FEEL THAT WE COME ACROSS AS SOMEWHAT INCOMPETENT.

DO YOU THINK THE WRITER IS TRYING TO TELL US SOMETHING?

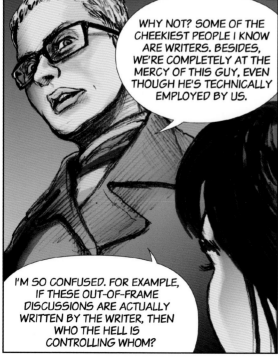

WHY NOT? SOME OF THE CHEEKIEST PEOPLE I KNOW ARE WRITERS. BESIDES, WE'RE COMPLETELY AT THE MERCY OF THIS GUY, EVEN THOUGH HE'S TECHNICALLY EMPLOYED BY US.

I'M SO CONFUSED. FOR EXAMPLE, IF THESE OUT-OF-FRAME DISCUSSIONS ARE ACTUALLY WRITTEN BY THE WRITER, THEN WHO THE HELL IS CONTROLLING WHOM?

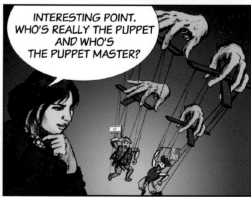

INTERESTING POINT. WHO'S REALLY THE PUPPET AND WHO'S THE PUPPET MASTER?

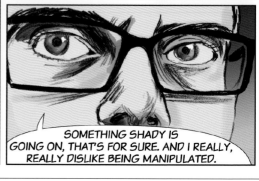

SOMETHING SHADY IS GOING ON, THAT'S FOR SURE. AND I REALLY, REALLY DISLIKE BEING MANIPULATED.

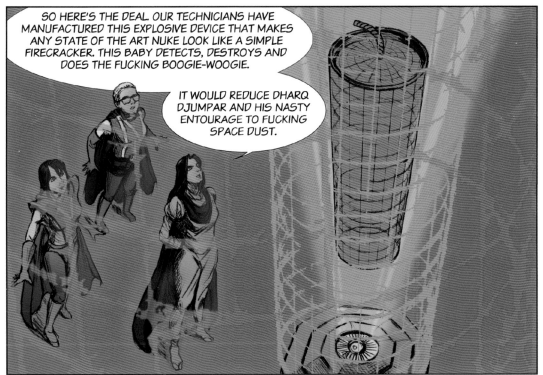

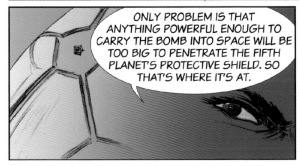

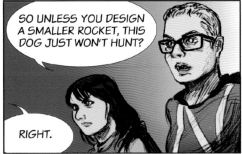

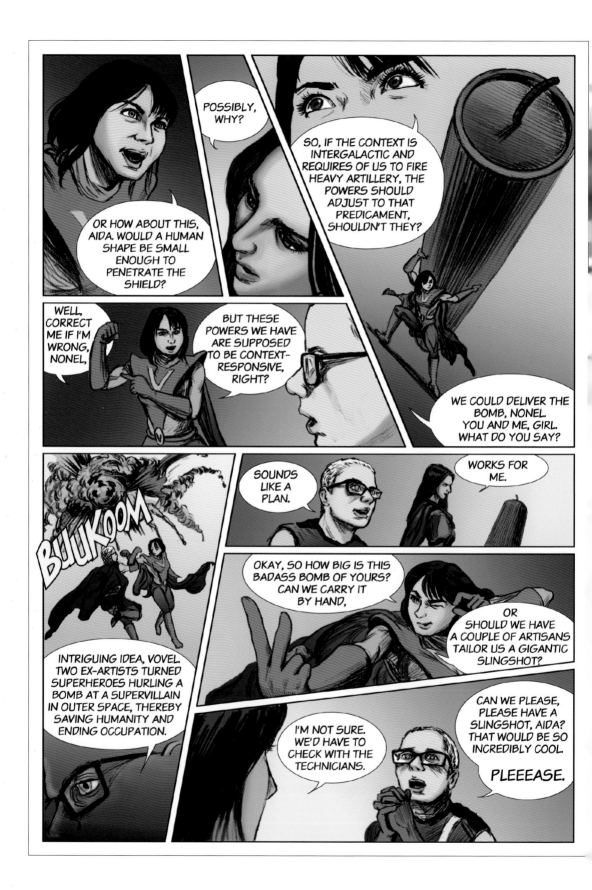

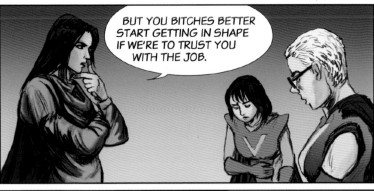

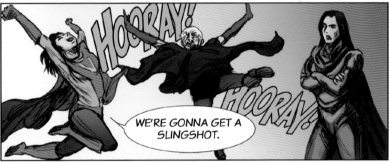

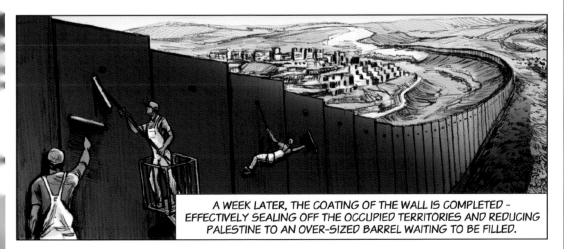

A WEEK LATER, THE COATING OF THE WALL IS COMPLETED – EFFECTIVELY SEALING OFF THE OCCUPIED TERRITORIES AND REDUCING PALESTINE TO AN OVER-SIZED BARREL WAITING TO BE FILLED.

MEANWHILE, AIDA IS PUSHING THE TWO SUPERHEROES TO THE LIMIT.

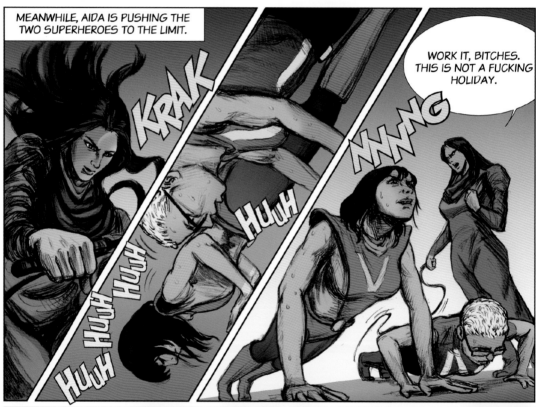

KRAK

HUUH HUUH

HUUH

HUUH

NNNNG

WORK IT, BITCHES. THIS IS NOT A FUCKING HOLIDAY.

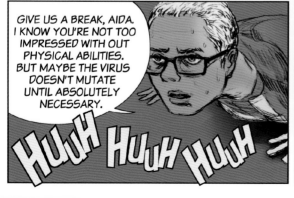

GIVE US A BREAK, AIDA. I KNOW YOU'RE NOT TOO IMPRESSED WITH OUT PHYSICAL ABILITIES. BUT MAYBE THE VIRUS DOESN'T MUTATE UNTIL ABSOLUTELY NECESSARY.

HUUH HUUH HUUH

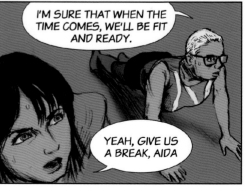

I'M SURE THAT WHEN THE TIME COMES, WE'LL BE FIT AND READY.

YEAH, GIVE US A BREAK, AIDA

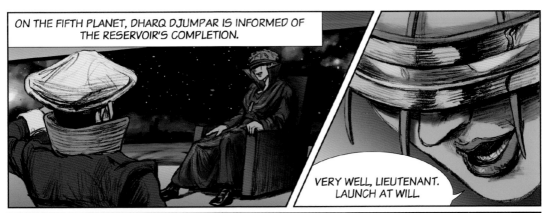

ON THE FIFTH PLANET, DHARQ DJUMPAR IS INFORMED OF THE RESERVOIR'S COMPLETION.

VERY WELL, LIEUTENANT. LAUNCH AT WILL.

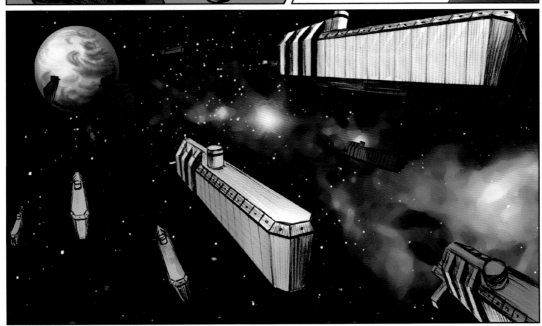

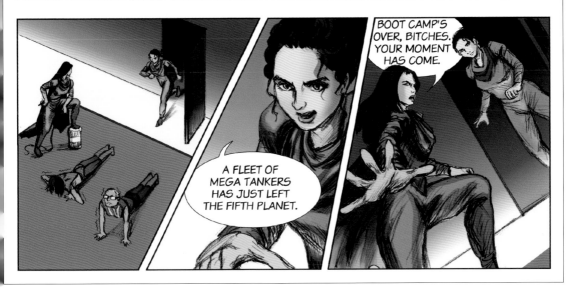

BOOT CAMP'S OVER, BITCHES. YOUR MOMENT HAS COME.

A FLEET OF MEGA TANKERS HAS JUST LEFT THE FIFTH PLANET.

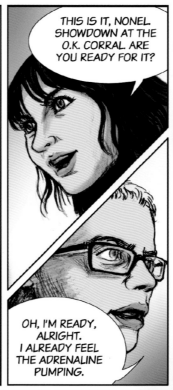

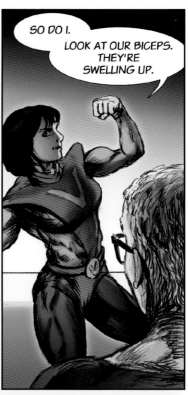

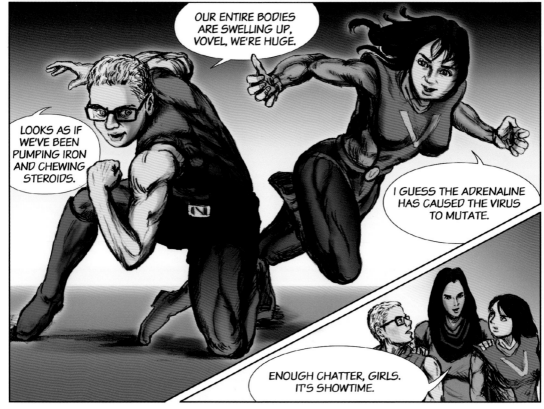

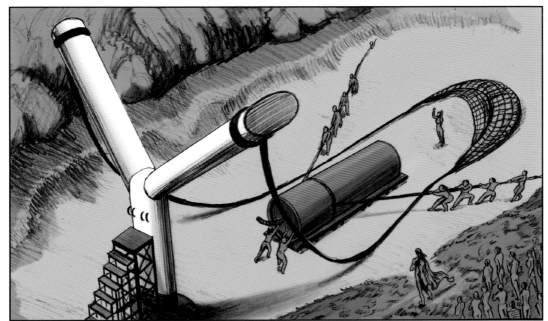

REMEMBER EVERYTHING I'VE TAUGHT YOU. HEAD DIRECTLY FOR THE FIFTH PLANET. SHOULD YOU PASS THE MEGA TANKERS ON THE WAY, SIMPLY IGNORE THEM. THEY ARE SET TO SELF-DESTRUCT IF THE PLANET SHOULD LOSE TRACK OF THEM. IT'S YOUR JOB TO MAKE SURE THAT THAT HAPPENS.

LET'S STRAP ON THIS BABY AND TAKE OUT THE BAD GUYS.

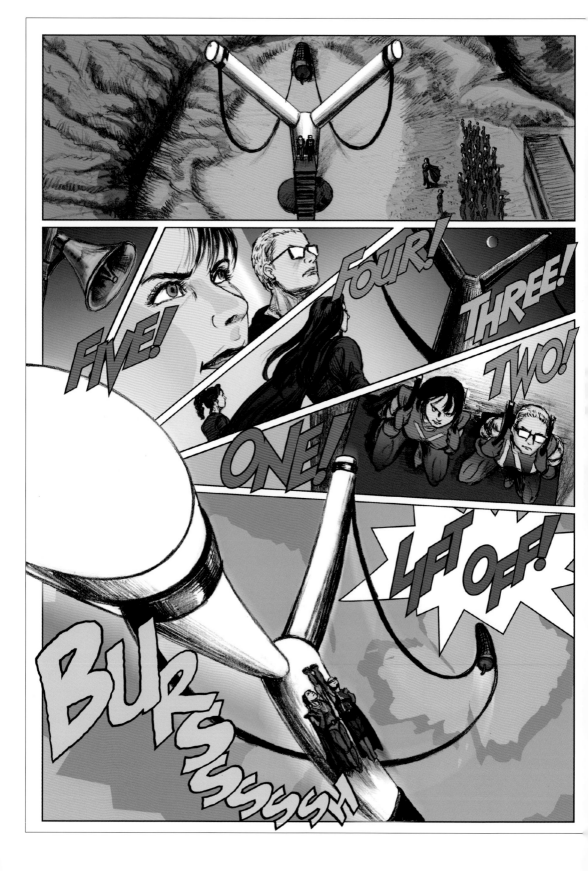

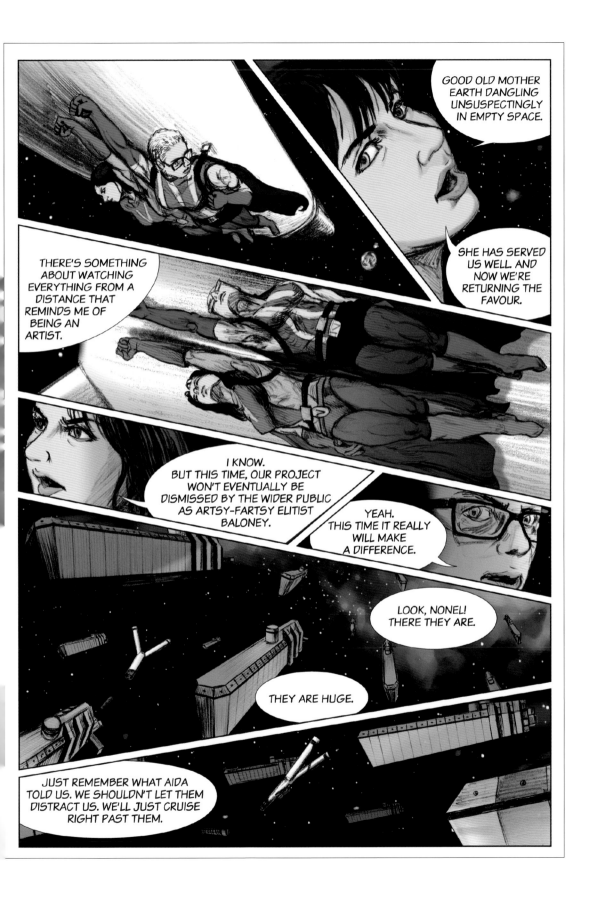

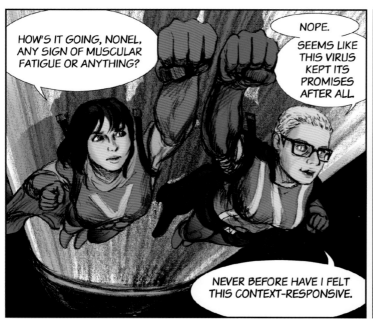

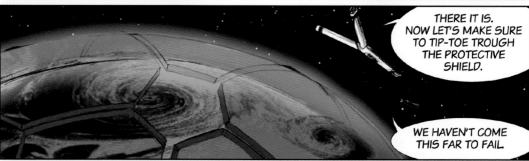

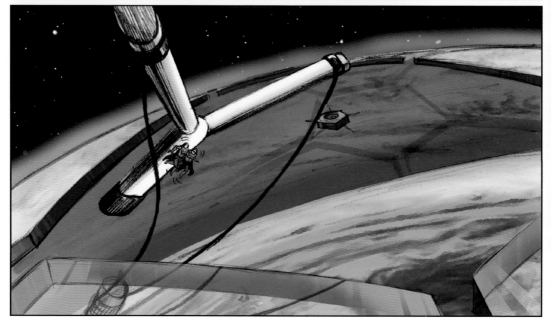

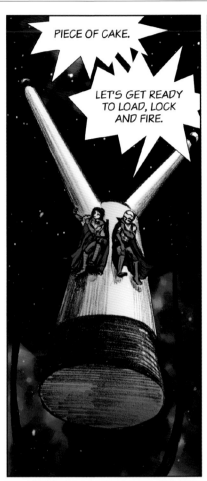

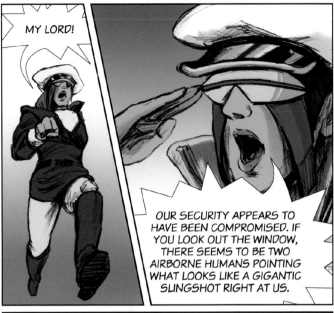

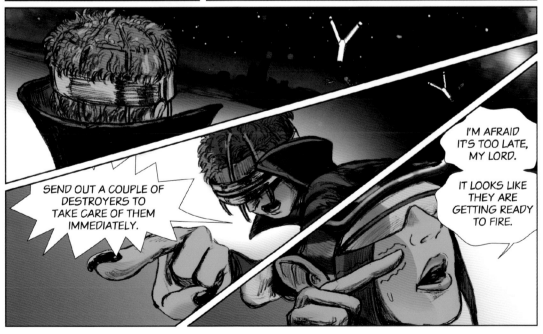

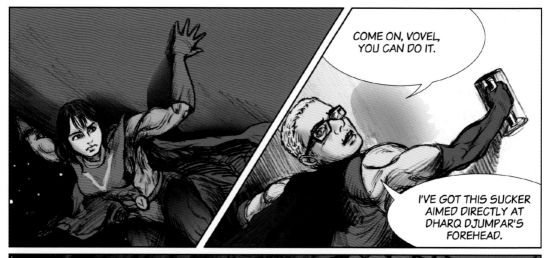

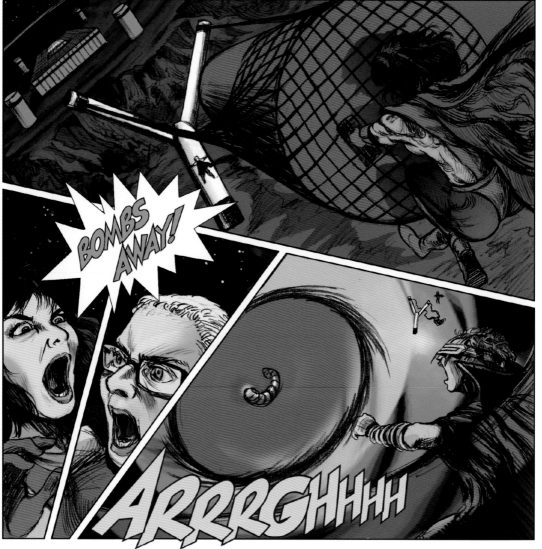

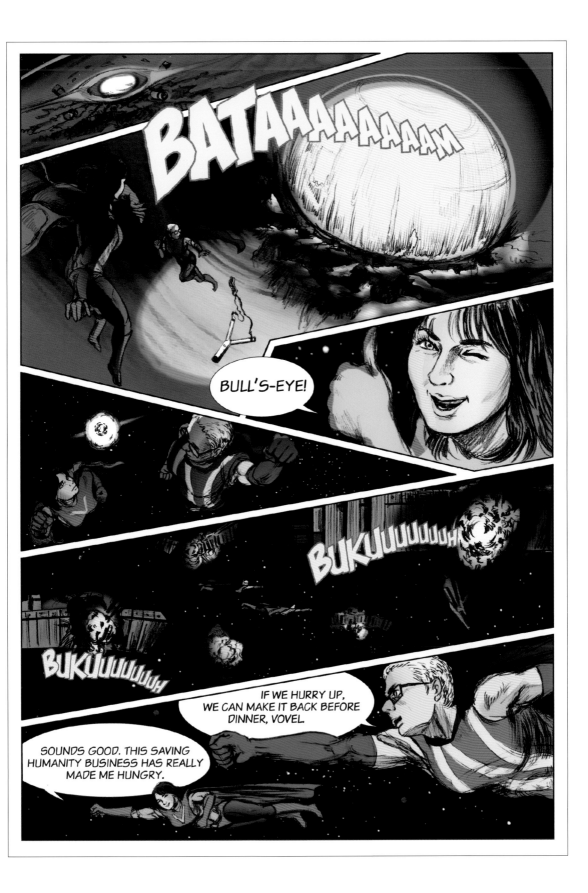

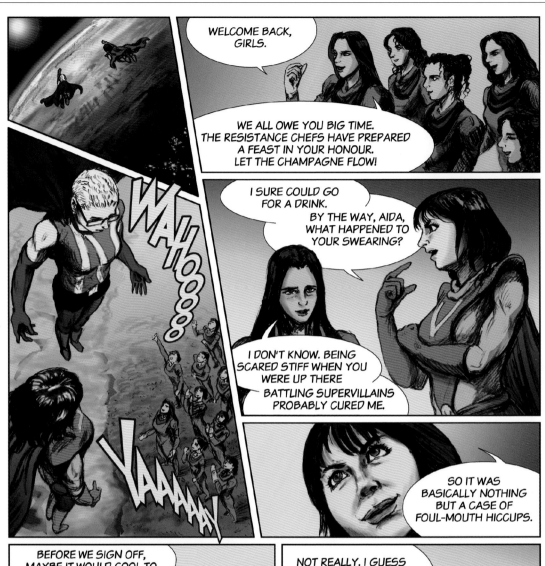

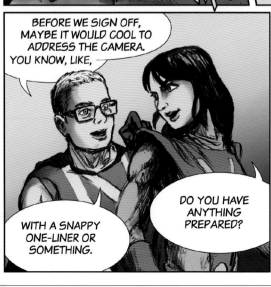

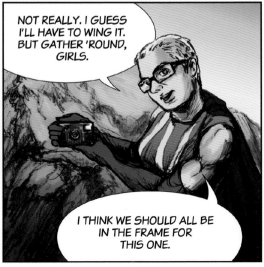

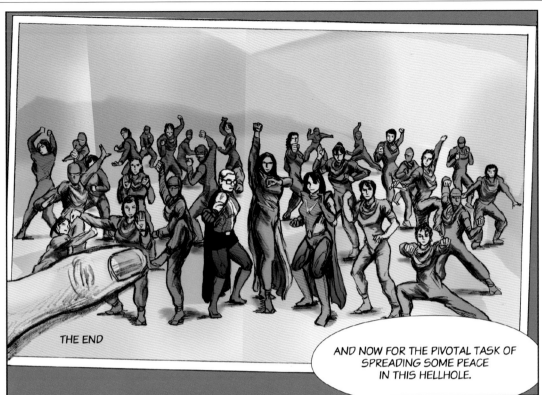

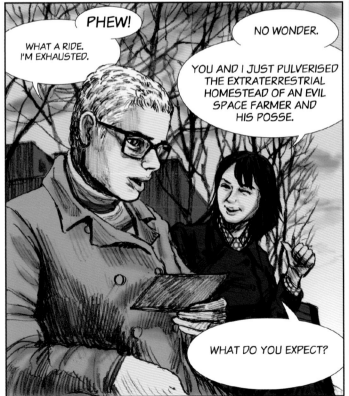

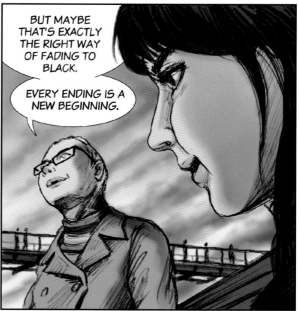

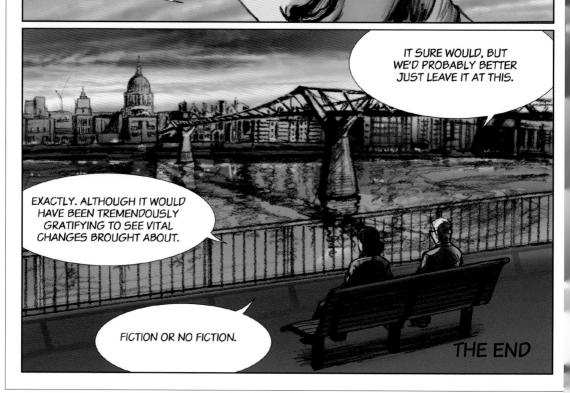

THE END

ESSAYS

NOT-YET-NESS: Towards the Intergalactic

Reem Fadda

Introduction

In a recent visit of the performance artist and curator Coco Fusco to the Palestinian Terri-tories, I asked her about her reasoning to the influx of professionals, especially art-related peoples, who were coming en masse to this troubled area. Her answer was that these people feel that they are in a place "where there is history in the making." History in the making is an interesting concept in this regard. This is a place where people understand that time is of consequence, and they witness that in "real" time. The present tense seems to be contribut-ing towards futurity or time continuum. In the concept of "our" time and space, I think it is important to really cap on how "our" aspect of understanding can become a platform for oth-ers as well, not in a way to essentialise or hegemonise but to provide an opportunity of com-munal practices and adoptions. Cultures are founded on cohabitation and shared-ness. The limits of the specificity of the context are meant to be broken up for a larger understanding and maybe even a solution.

Currently, the Palestinian question has entered an interesting phase. With a collapse of functional politics and a spatial metamorphoses or disfiguration, we have come to face a new set of questions regarding its "nationalistic" project. In what seems to be a time of stagna-tion, I see it as a time where existentialistic formulas need to be re-asked and reconsidered within parameters of the known. What happens when spatially, hysteria leads to physical dis-integration of applicable spatial logics? And ideas of what constitutes the norm are being derived from political and social practices that are clearly reformulated and reexamined organically yet impulsively? This is a place where nationalism is being questioned altogether; belonging, patriotism, identity, and the jumble of adherents of nationalism along with it. I find that it has entered the "not" zone where everything becomes possible. I would even go fur-ther to vouch that this state of stagnation and digress can become a place of surrender for claims of universality. It is an open space for contemplation in order to answer existential dilemmas that are not just for the Palestinians or the Israelis, and it's about time as well. Imaginings become necessary for provisions and scenarios of futures, together and with oth-ers. And maybe this is all daydreaming or wishful thinking.

I recently attended a conference organised in New York City between CUNY and Columbia University on "Crisis States: The Uncertain Future of Israel/Palestine". It was quite interesting to see that it was not only myself or the myriad of artists I know who were obsessing about this question of futurity, but also the academics. Voices were raised asking direct questions related to its past and future. Questions of temporality, spatial rationale, and existential con-tinuum are of essence here, in Palestine and Israel. We need to find formulas of how and what shape the foreseeable future could persist on and like. Maybe those formulas need to be created from a jumble of elements brought on by reality, theory, and aesthetic interpreta-tion, but stirred with a huge dollop of openness and a drive stemming from reclaiming agency through decolonization towards the future.

I find it most interesting that a place like that still manages to serve as a clear case of modernity. In this context, the actual severance from history from the time of the 1948 War (Al-Nakba) and many unfolding realities that have ruptured geographies to Bantustans and enclaves in our day, all have compromised this sense of continuity in our understanding of time. And I would claim that this continuous radical forced rupture with our past transforms it into an obsession with our timelessness; our contemporaneity is heightened and so is our futurity. And duly and obsessively, we never forsake the past. Hence a new set of vocabulary is created for the interpretation of our modernity, one that is especially characterised by a forceful relationship with our time. The violence of these ruptures recalls the need for strata-gems of dealing with an exceptional reality of time. And this interest in time makes it for me ever the more a political act. So we find that we have many attempts that fall short from the

messianic and in their simplest form are attempts at liberatory politics.

However, I for one prefer renditions of the aesthetic type because they offer a close understanding of this reality. For if art is the area that is not only capable of marking change but also of interpreting the worlds we are in and a space for free speculation and reflection to voice our concerns and ponder existential dilemmas, then it could offer a good representation for my claims.

Therefore, I would like to anchor my theoretical analysis on the topic of our temporality and futurity in the Palestinian/Israeli reality, with insight into the works of the artists Oreet Ashery and Larissa Sansour, particularly their joint project *Nonel & Vovel*, which becomes a marvelous anecdote and strong point of reference and conclusion.

Not-yet-ness

I would like to highlight a temporal term I came across in reference to the Palestinian question in an article by Professor Grant Farred, "Disorderly Democracy: An Axiomatic Politics", which I find adds to the notion of history in the making. The term is "not-yet-ness". He used it more to reflect on the current state of affairs of the nationalistic project taking place in Palestine, and I found the term very appealing context-wise and also in its temporal "potentialities", according to Agamben. Of course the term "not-yet", in its literality, is not new in its philosophical expansions. I will retrace it back to Heidegger, Benjamin, and Iqbal.

First in the crude political interpretation of the Palestinian context, not-yet-ness confers to that of a state of not being a state. Or a sovereignty in the traditional sense of the word that is not fully reinstated or wants to create its own permutations and understandings of what constitutes a sovereign project. According to Farred: "The Palestinian's is a struggle for and against a sovereignty whose not-yet-ness, whose persistent incipience, constitutes the very spectral substance that undermines all those other adjoining, contiguous sovereignties . . ."[1] So in this meaning, the Palestinians have the agency to claim, interpret, and create viable understandings of sovereignty away from didactics of enforced power relations. Here we begin to see the hints alluding to self-proclamation and calls of decolonization.

And in unpacking the term "not-yet-ness", within that context from a more theoretical point of view, we find that it unfolds many meanings; that which is and which is not. Or that which has the potential to be, but is not. And I insist on making clear that my major attempt in understanding the temporal aspect within this sense is by conflating it with human agency. So in this permutation, it becomes very interesting to see that this term conflates with the Agambenian notion of "potentialities" in that it always retains the negative or a state of "lackness"; the same state of "lackness" or "not-ness" that invokes a restless sense or need for change brought about by the subject's ability and knowledge to realise one's "lackness". According to the interpretation of Alam Khundmiri about the poet Iqbal, "to be potential means: to be one's own lack, *to be in relation to one's own incapacity*."[2] For potential in this understanding holds the possibility of becoming an actuality, very similar to that of the not-yet, but also it holds the potential not to be or not-do.

The major claim that I find so evident in this concept is that of agency and "action". The "to do" is the real source of energy that also finds itself attached to a temporal reality and always somehow seems to be neglected or undermined. The spirit of "to do", "to make", "to build", "to create", and many other verbs that denote action become highlighted within this context, again showing how action becomes enjoined with the temporal. In addition, the highlighted rigor in this concept is its inexplicable cycle of self-regeneration. Agamben insists on highlighting words of action like that of "having". He is primarily concerned with how potentiality retains "knowledge and ability".[3] To be capable of harnessing your own "absence" or your own "privation" means that you have "faculty" and "power". And in this instance you assert your capacity of garnering free will and agency. "To be free is . . . *to be capable of one's own impotentiality*, to be in relation to one's own privation."[4]

The term's temporality, which evokes a strong reference to futurity while still anchoring on a present and past, is fascinating. The poet Iqbal has always established modernity as that which is projected towards a future, and one that was simultaneously always driven by a past. The "not-yet" is a constant visitor in his poems.[5] This references Heidegger's *Dasein*, which sees its Being-in-the-world as a perpetual, a hermeneutic continuum, empowered by a

sense of agency, free will, and awareness.[6] Iqbal has seen the importance of assuming a non-fatalistic attitude towards the world, one where again agency and transformation unfold. "Iqbal is in full agreement with the humanists that man makes his own history . . . Iqbal would have agreed with Heidegger that destiny is a mode of authentic existence and that everything does not have a destiny. If a man becomes a thing he loses his destiny, he acquires it by becoming free. To act freely is to act historically, and to act historically is to defy death."[7] So in acting within the parameters of the not-yet, the person claims agency and free will, in order to act on his potential and with knowledge that he is doing so in a historical framework, owning his history and thwarting towards a future.

Agency and the Messianic Drive

Not-yet in its capacity to incorporate all tenses, leading to futurity, still is a phrase with a negation. However this status of negation or not somehow manages to create an assertion, alluding to a somewhat prophetic force or voice of that which is about to happen. Free will and agency are conjured to assert the future implicit in the not-yet. In this prophetic drive we are brought to messianic interpretations that seem to have also been quite natural to this place. The agency we have spoken so vigorously about is now capped in individuals who seek change. Time again here conflates with the subject. Messianic time renders prophets of "radical change" as Iqbal refers to them. According to the intellectual Alam Khundmiri, Iqbal's understanding of the role of prophets was that:

". . . a prophet becomes a destroyer, a creator, and an agent of change. Iqbal's strong passion for the prophetic example does not betray his revivalistic attitude; on the contrary, it indicates a passion for time as against the static eternity of the mystic, a search for reality in the process of becoming rather than a changeless being, a passion for striving against the traditional quietist attitude, and, above all, a desire to plunge into the process of history for the creation of novelty".[8]

The need becomes insurmountable in the state of the not-yet to produce those agents of change. Active ruptures, carried about with agency and a revolutionary drive, counter violent ruptures in time that had aimed at severing the past from the present, as in the case of the colonial occupation of Palestine. The aim is to stride away from our timelessness and recapture our past with messianic force. This of course is very much also an understanding that is inspired by Walter Benjamin's stand on history and need for change. The messianic or revolutionary moment is to be conceived as a rupture or an interruption of the current situation. This is an important transformation in the idea of what constitute revolutions, because it has long been regarded as the end-point of progress and of historical development. Revolution is therefore theorised as an element in the norm of progress, whereas disaster and crisis are intrusions. Benjamin turns the tables around, with revolution becoming the interruption of progress, conceived as a cumulative development of the logic inherent to the disaster, which is immanent in the present.[9]

The messianic translatability from Iqbal and Benjamin, both meeting at a reclaiming of the past through adopting change as a catalyst. This brings the revolutionary mode into a new set of variables and a new role in relation to our history and time. In the not-yet of our times and within the Palestinian situation there becomes an insurmountable desire to recapture our sense of time through emanating our agency and through provoking change, real change.

Nonel & Vovel and the Universal Past

The Novel of Nonel & Vovel is a caricature story of the relationship and discussions of two artists, Larissa Sansour and Oreet Ashery. Sansour is Palestinian and Ashery is Israeli and besides being two artists who have worked very much in the performative sense, both have a real interest in engaging in their contextual political realities in the attempt at finding remedies.

Larissa Sansour has produced many works that deal with the Palestinian home. *Bethlehem Bandolero* (2005) is a video piece in which Larissa Sansour, clad in sombrero and bandanna, plays the lead role in a classic Western gunfight against an intimidating opponent: the Separation Wall in Palestine/Israel. In this video piece, there is an interesting play on the futility and ridiculousness of both the kind of action utilised and the object under assault.

We can see another play on the context yet towing with a more somber tone, in the video piece *A Space Exodus* by Sansour. In this film she toys with Stanley Kubrick's *2001: A Space Odyssey* but subjecting it to a Middle Eastern political interpretation. There the homeland becomes far out of reach. Conflations, juxtapositions, and paradoxes of times, histories, and geographies are all issues at stake here. They are woven in a playful circumvent of a fantasy world, filled with aspirations and faced with limitations.

Welcome Home is a multi-faced project conceived by Oreet Ashery, where she conducts a gathering or a party "for those who are not allowed to return," alluding to the case of the displaced Palestinian refugees. She also gives out a performance entitled *Memorial Service* as part of the above-mentioned project, where she reenacts being an army general who wildly resembles Moshe Dayan especially with the patch on the eye, and while three Palestinian voices recite the names of 369 villages that were destroyed during the formation of the state of Israel after the 1948 War. The general mechanically shreds 369 envelopes with the names of the villages written on them.

Present

I think it is rather interesting to see the correlations of thought in both the artists' previous works. They have resorted to the performative, playing on gender reversal in many instances. They have abundantly asked the questions that point back to the Palestinian/Israeli context, with a heavy sense of responsibility and chagrin that they have faced by resorting to irony and many times succumbed to the somberness of it all. There is an obvious attachment to notions of history and even an attempt at remedying it. If there had been a profiling gauge as how to pair artists, the result would have naturally led to those two together! However the thing I would like to highlight the most about the work of the two is their seeming adherence to ask the bigger questions: how do we resort to real action in facing a situation that demands "real" and immediate change?

It is no surprise that both artists have taken this question up to the challenge with full force in their latest project together, *The Novel of Nonel and Vovel*. They tackle the dilemma of the role of aesthetics when mediating larger political questions. What is the role of the artists as artists within this equation? Does art suffice to implement change? Art does seem to suffer an impasse – especially when heavily inundated with market rhetoric, institutional critique, and bureaucratic jargon. Art has long had a relationship to politics, but how do you attempt at reinstating that? This question becomes pertinent to artists coming from the troubled region. Their previous work shows their personal hypersensitivity to the issues relegated to the time and space of where they come from. Their joint project confirms to me more than one conclusion. Those artists have marked the impasse in the times that have passed, yet they obviously still seemingly sense the enormousness of the impeding temporal question, rising from the Palestinian dilemma, particularly one that is spurred towards imagining a future. And imagining a future is precisely what they set to do.

In *The Novel of Nonel and Vovel*, they resort intelligently to the comic book style, a natural visual development of both their witty artistic work, one that is set in an imagined future but still dealing with Palestine and Israel. In it they weave science-fiction stories about the adventures of Nonel and Vovel, which are characters based on their own personas. Nonel and Vovel transform into superheroes after having been injected with a virus that causes a reversal to their status as artists. At one point they are faced with the choice of staying artists or becoming superheroes, only to find that the choice is irreversibly towards the latter while their preference is the former.

Faced with being superheroes, it recalls the need for messiahs – that incessant need and drive that has long been an evocation and production of time. The artists have pondered the same aspiration of reclaiming agency. Their superhero attire in this story becomes very much a messianic reinstatement, one that can be interpreted as a call to transgress times of potentialities into ones that are marked with action. How does art transform into becoming synonymous to "action" in the traditional sense? For example, their dissatisfaction becomes evident in how they criticise the jargon that is recycled in art circles. Nonel and Vovel go on a journey to Palestine where they are intent on bringing change and facing the occupation. They fantasize about the things they want to do. They want to eradicate the Separation Wall and face

the occupation army forces. Their to-do list becomes preposterous when they realise that the whole occupation of Palestine is in fact an intergalactic strategem from the 5th Plant run by the villain Dharq Djumpar, beyond even the knowledge of the US and Israel, to transform the Earth into an intergalactic vegetable garden and eradicate humanity! But they do not stop there and team up with the resistance group, which is made of a group of women ninjas . . .

Future

I think the most interesting part for me in the narration of the story is their play on history and how they strive towards an active futurity. First, the plan of events seems to have a life of its own, a way to insist on the continuity of history. And again it is no coincidence that the story is placed in the future. How else do you imagine one for this region? In addition, during the narration of events, the characters would then jump out of the storyboard and discuss things as their usual self on the side, in the present tense. I think this sort of perpetual rupture is intentional. It serves as a reminder of the present tense and a past they leave behind. What is implicit is that it's a future anchored from a past discourse. It all becomes directly referential to conscious thought.

They fly to London, they fly to Palestine, and they even reach the out abodes of space. Geographies and placements become meaningless. It is a constant reminder of the stateless, the restless, the not, and the not-yet-ness. Stateless, because of the current realities and global ramifications that create new realities of perception. Here the diasporic is a state of becoming for the artist, where he transforms into a worldlier figure. Restless because there is always an insurmountable need for action, especially not surpassing the dire realities evoked. The not becomes pertinent because in the state of negation agency needs to find a stepping-stone towards assertion. The not-yet-ness is that of the state of being of the place and our times and a real struggle towards a future. And it all becomes a call for something that goes beyond the confines of specificity towards a "bigger picture". Maybe something intergalactic . . .

1. Farred, G, "Disorderly Democracy: An Axiomatic Politics", *The New Centennial Review*, vol. 8, no. 2, 2008, p. 59.
2. Ansari, MT (ed.), *Secularism, Islam & Modernity: Selected Essays of Alam Khundmiri*. New Delhi-London: Sage Publications, 2001, p. 189.
3. Agamben, G, *Potentialities: Collected Essays in Philosophy*. Stanford: Stanford University Press, 1999, p. 179.
4. Ibid., p. 183.
5. Ansari, MT (ed.), *Secularism, Islam & Modernity: Selected Essays of Alam Khundmiri, Op. cit.*, p. 214.
6. Heidegger, M, *Being & Time*. New York: Harper Collins, 1962.
7. Ibid., p. 186.
8. Ibid., p. 181.
9. Benjamin, W, *Illuminations: Essays & Reflections*. New York: Schocken Books, 2007.

Proposal for the Venice Biennale Intergalactic Pavilion.
New Nonel&Vovel Commission: *Heroism: An Epic Out of the Frame*

Curator: Nat Muller

To: The Intergalactic Council of the Arts
Odysee Building, 113th floor
Stellar Avenue #4
District X-Y3
6th Planet

Reference: Concept Proposal for 2212 Intergalactic Pavilion

Dear Committee,
On the occasion of the 10th anniversary of the Intergalactic Pavilion at the Venice Biennale, here lies before you the proposal *Heroism: An Epic Out of the Frame*. It is with great pleasure to announce that the well-known artist duo **Nonel and Vovel**, after embarking respectively on successful solo careers after the liberation of Palestine, have agreed to take up once more a collaborative project. I hope you are as excited as I am at the prospect of newly commissioned work by these two remarkable artists, and will agree to support this project in your fullest capacity to see it come to its fruition.
I remain at your disposal for any further questions or queries.

Sincerely,
N.M.
(Curator of the 10th Intergalactic Pavilion)

Introduction

The Intergalactic Pavilion has since its inception in 2192 focused on cross-planetary exchange and inter-species dialogue. While this agenda has yielded numerous collaborations, has been fruitful for short-lived moments of individual curatorial glory, and has fostered soft inter-stellar diplomacy, the actual artistic outcomes have been mediocre. The latter is not a novel complaint, as age-old critiques on the instrumentalization of art have cluttered many a degree program. Nevertheless, it seems our learning curve is slow: an emphasis on the didactic, celebration of the alien, and overt consideration for trans-galactic sensitivities have produced an artistic practice that is meek, unchallenging, and monolithic.

While the choice for two earthling-artists might seem unorthodox in some quarters within the framework of the Intergalactic Pavilion, we are *de facto* sending a strong message that it is not territorial or extraterrestrial origins equipping artists with the ability to transcend and comment on confining ideological dichotomies, but rather that it is the freedom to consciously ignore those, and by corollary make us see things anew, that signifies the creative act. In our conception the notion of true intergalactic citizenship lies within the capacity to embrace that freedom: Nonel and Vovel's work has been exemplary in this respect.

In many ways our proposal is a manifesto for the arts post-liberation. After the destruction of the 5th Planet, the subsequent liberation of Palestine and all other earth-bound civilizations, we have witnessed 300 years of global peace and stability. This defining moment has also marked the death of context-responsive art and the redundancy of socio-politically engaged artists as formerly known. Referred to as "the rupture", this breaking point caused a severe crisis in the early twenty-first-century art world, and we still detect its ramifications to this present day, our contemporary artists have plainly ceased to generate meaning able to transcend the manifest present. Therefore, by placing the artistic process firmly at the center of the collaboration, and eradicating compromising positions caused by three centuries of the neo-mimetic, we propose a truly radical stance in an era of harmonious dissociation: subjectivity through epic self-referentiality. Rather than responding to any given context, this project

creates its own. It re-inserts the transformative role of art and the artist, and the creation of alternative subjectivities and positionings, surprisingly by ways of historical repetition.

Historic art movements such as the twenty-second-century *Terra-nostalgics,* who functioned as *agents provocateurs* attempting to sow strife and mayhem, in order to create that long lost "rub" or "tension" with an imaginary hegemony, or the *atavist conceptualists* of the late twenty-first century who had a stint at melting the already melted icecaps, have eventually failed in their mission. In this respect we can conclude that not only have we lost our utopias, but have in a similar vein also forsaken our dystopias. If the previous centuries have struggled to position art as resistance, art as conflict prevention tool, art as onanism for an uninspired intelligentsia and failing governance, or art as liberation, then we firmly reject the position of the artist as (symbolic) messenger. We embrace the artist as hero, as super-hero more precisely, just because beyond liberation it is the sole gesture left. We offer a commodity weighed down to its net and naked essence: the artist, stripped of all societal noise and political excess luggage, a taste of pure aura. By corollary we re-install what has been discarded and neglected for centuries: true iconographic (super)power.

Concept Motivation and Summary
Our main source of inspiration is the seminal text "Heroism as Masquerade", which uncovers the performative strategies behind the heroic. The author posits that it is the heroic performance act which defines and marks someone as a hero. Yet heroic subjectivity is always produced through a repetitive symbolic re-enactment of that very first transformative act. In other words, the act functions as an identitarian cloak – or in the case of Nonel and Vovel a cape – tagging the subject. If indeed masquerade is the means by which heroism is produced, then heroism is in and of itself a masquerade, and only exists by grace of the latter. Under the mask, we find nothing. In addition, the heroic act is always dated, but the heroic epithet is eternal. These convoluted dynamics beg for an epic meta-structure to support its unstable ontology.

Heroism: An Epic Out of the Frame is a call to go back to basics. The artistic practice of Nonel and Vovel is one that has consistently risen "out of the frame", whether considering tactics, collaborative methodology, media, or subject matter. Their work has been read as postnostalgic, since the spectacle has been fully evacuated post-liberation. Given the significant role they have both played in the liberation of Palestine, and the destruction of the evil plot of the 5th Planet consortium, it is remarkable that after so many years and various multi-faceted projects, they have remained true to their original mode of collaboration, which is characterised by a fluctuation in and out of the frame and by what some theorists have called a "processual hesitance". In their solo projects they have explored and tackled issues such as space travel and trans-galactic mobility, redirective artistic roles, cosmo-hedonism, orbital identity, and the shifting boundaries of superhero aesthetics.

For the 10th edition of the Intergalactic Pavilion, these fine artists have been commissioned to create a new piece of epic magnitude, befitting the artistic challenges at the turn of the twenty-third century. While subtly critiquing the institutional framework of the Biennale and its respective pavilions, which after the abolition of nation states in 2117 have for tradition's sake still attained their folkloric and representative function, and referencing the quashed Biennale Coup of 2099 by the AAA (Alien Art Astronauts), as well as the Biennale Treaty of Eternal Sustainability (Venice, 2168), this work first and foremost seeks to be an inspiring and thought-provoking cause for a paradigmatic shift. *Heroism: An Epic Out of the Frame* returns to the idea of exhibition as narrative space. It aims to offer a scenario across the time-space axis, with clear protagonists and multiple storylines. The artists do not seek the heroic of everyday life, or in the mundane, but rather in this new work materialise the self-referential supra-text, which is devoid of cause or functionality. In other words, the ethics of the epic, and the purpose of artistic labor post-liberation are excavated.

Here the role of the audience becomes fundamental, as they simultaneously perform the role of consumer archeologists. Post-liberation the sensibility an audience craves most is the elated feeling of the saviour. In the contemporary art world, and in an era of high-sociable responsibility, this is a desire oft frowned upon. Nevertheless, carefully controlled and designed momentary lapses of total surrender, and irrational trust in a force larger than oneself

(the super-heroic), is a necessary and healthy psychological stress valve for any post-liberated society. The temporary migration of responsibility to the super hero/artist offers the audience the comfort(ing) zone they seek. In addition, it is the fine balance between the tangibility of performing the heroic and constituting (physically embodying) the heroic that opens up a perceptually responsive space of intimacy. Nonel and Vovel simultaneously inhabit the iconic and archaic qualities of the Fedayeen (freedom fighter) and the Messiah (savior), but in their work still afford a close proximity to their audiences. For the audience this results in a close identification with the superheroes, and cathartic wish-fulfillment in an era where there is nothing left to save, nothing left to truly fight for.

Therefore, this Pavilion can only be a celebration and glorification of the super hero/artist as herself. Monumentalised across multiple intergalactic locations, the epic of the Liberation of Palestine and the destruction of the 5th Planet, will be dramatically re-enacted again and again, across every medium possible, looped ad infinitum until our semantic memory collapses, and the only thing we can discern is form.

Format and Components

This ambitious project first and foremost makes use of the unique sub-aquatic properties of sunken Venice. The artists intend to use the water surface as a holographic device for the looped image sequence. Strategically mounted trans-orbital spatial sound systems provide for the audio elements. In the Pavilion space itself and across the Giardini, the performative act of heroic masquerading is choreographed into a live installation by an assembly of Nonel and Vovel clones. It is important to have their serial numbers and date of production clearly indicated, so that the audience's experience of authenticity is genuine in its various degrees, and mediated with integrity. As aforementioned, the system is programmed to run until the narrative is reduced to pure form. Once this phase has been attained the audience is teleported to a new venue where the same scenario recommences. The actual artists Nonel and Vovel make a heroic intervention entrée on location at the beginning of each new sequence. The impetus of the superheroes materialization is to counter the representational, and offer masquerading illusion for what it is, namely the real. This stage of the project is still in full development.

During the duration of the Biennale a comprehensive program of side events – from presentations to workshops – will take place. Though still in their conceptual draft, we have already secured a workshop about trans-terrestrial mobility for the cosmologically impaired; a seminar on superhero design issues for students at the Confederational College of the Arts, as well as a panel on the aesthetics of Post-Liberation Epics with experts in the field.

At the time of writing, we have struck up collaborations with fellow institutions and organizations across our universe and the broader galaxy. Notable partners are the X-line Gallery on Luna #3, The Newest Museum in New York, Luna #7 Art Initiative, the 6th Planet Arts and Heritage Association, and the Cosmo-Consortium at Saadiyat Island. We are still negotiating with the group "Artists without Universes" for infra-structural assistance, but are confident once we can secure the base part of the funding they will join us in this venture.

[A detailed list of technical specifications and required resources is available upon request.]

Objectives

Tackling pressing issues of a Post-Liberation Universe through a non-threatening mechanism, which will not by any means destabilise universal peace;
Fostering true intergalactic citizenship by capitalizing on the obvious;
Creating a platform to critically review the role of the artist vis-à-vis the heroic;
Offering a new artistic vision and direction for the Intergalactic Pavilion;
Shaping an opportunity for two outstanding artists – currently popular as solo artists – to create exciting new work together, while at the same time performing a homage to their previous work;
Engaging a wide audience to immerse themselves in the epic and reality-transforming tale of Nonel and Vovel;
Carving out a definite place in the Annals of Intergalactic Art History for Nonel and Vovel.

Foreseeable Obstacles
Production/Technical

We are slightly concerned by the unstable meteorological conditions across the Mediterranean. Torrential rains, sub-marine tempests, and quakes have caused disruptions of the aquatic surface, which is of utmost importance for the image part of this project. Our team of scientists and engineers are currently researching our technical options and possible solutions. In addition, consumer reports have not always been very favourable in relation to experimental teleportation technology. Our juridical experts are investigating conditions of usage and terms of liability for artists, the Biennale, and the audience.

[Full reports and studies are due shortly and available upon request.]

Security

It has come to our attention that a small cell of neo-beta-settlers who categorically deny the Liberation of Palestine and the destruction of the 5th Planet, inspired by colonial and expansionist ideologies of the nineteenth, twentieth, and early twenty-first century, have increasingly been attracting followers. Though the authorities have assured us that there is no threat whatsoever, and that the ludicrous conspiracy theories of the neo-beta-settlers are perfectly innocent, amounting to nothing more than infantile and de-historicised fact fabrication, we think vigilance is recommended. We have notified the Inter-Stellar Security Board, and have asked them to monitor the situation closely.

Target Audience

With this project we hope to appeal to a large and heterogeneous audience across the stars. The attractive format and content make this a low-threshold and accessible project to those who might not necessarily be interested in the arts. In this sense we do hope to target new audiences with this piece. The Venice Biennale has always attracted a constant flow of art lovers from the general public, as well as art professionals. We are lucky to be piggybacking on that context for our visibility. Delving deeper into the projected ramifications of the project, we hope the latter might be a catalyst to regroup the efforts and needs of superhero artists into a more organised fashion, by ways of a cross-orbital syndicate.

PR & Communication

While the Biennale has centuries of experience in advertising its events with state-of-the-art technology, we will undertake an accompanying PR and communication trajectory in a media campaign targeting strategic media partners and audiences. As usual there will be live pan-Galactic coverage for the whole duration of the event, updated to the nanosecond in all known galactic languages. Press reviews, reports, clippings, and updates will be distributed immediately to those registered in our expansive database.

We will organise special VIP previews for Friends of the Biennale, and important critics, curators, artists, and journalists across the galaxy. We are pleased to have secured a keynote speech at the Pavilion's opening by Professor Gibora Bint Batalah, the renowned post-liberation theorist and expert on the aesthetics of the heroic.

We are collaborating with an outstanding PR company specialised in the genetic and societal manipulation of artistic appreciation. They are preparing a program comprising hi-art enhancing nanobots for cardio-vascular use, pheromonic ads, synaptic mailing lists, and more traditional communication techniques such as web 8000.5 applications and sensory delusion. The latter will trigger and ensure interest from even the majority of our universe. Space shuttles linking the outer end of the universe with Venice will be accommodated.

[A detailed list of media partners and juridical disclosures regarding terms and usages of consumption enhancement, under article 4.3. of 23rdC Inter-Stellar Confederational Jurisprudence, is available upon request.]

A Crossword from the Holy Land Answers

¹H	A	M			²M	³A	N	N	⁴A
O			⁵U			L			S
M			M		⁶A	L	L	A	H
O		⁷A	M	⁸U		Y			
U			⁹A	S	¹⁰S			¹¹H	
¹²S	I	¹³N		¹⁴A	I	R		E	
		A		X		¹⁵Y		B	
¹⁶H	A	K	I	M		¹⁷E	M	I	R
		B				H		E	
	¹⁸M	A	G	I		A		W	

Appendix

Biography

Oreet Ashery is a Jerusalem-born, London-based visual artist, working in live art (performance, interventions, interactions), video, images, and objects, in context-responsive and site-specific ways. Ashery's work deals with intimate narratives, real and fictional, and their relationship to contested social and political realities. The work aims to expand the discourse around subjectivity and artistic practice, mainly through the use of various male alter egos and fictional characters that tend to refer to the cultures of minorities. The work is complex and relational, yet humorous and accessible.

Ashery has an ongoing interest in Jewish identities and histories and their relationships to Western and Eastern cultures and ethnicities. Over the years Ashery has created art works within the anti-occupation remits and in support of the Palestinian Right to Return, in a series of collaborative projects entitled *Welcome Home*.

Ashery performed and exhibited extensively in international contexts including art centers, museums, cinemas, galleries, film and performance festivals, and biennales. These have included the Liverpool Biennial, ZKM, Tate Modern, Brooklyn Museum, Pompidou Centre, Freud Museum, Umjetnicki Paviljon, NRLA, and Foxy Production. Site-specific locations have including curators' bedrooms in various cities, religious celebrations, a Qualandia checkpoint, and a derelict fishermen's hut. In 2009, Ashery will complete an Artangel public art commission.

Ashery's work has been published and discussed in numerous books and art publications in many languages. Books have included *Art in the Age of Terrorism*, *Art Tomorrow*, *Blasphemy Art that Offends*, and *Biographies and Space*. The book *Dancing with Men*, charting ten years of interactive performances and interventions, published by the Live Art Development Agency, will be available in Spring 2009.

Ashery is a recipient of an AHRC creative fellowship award. She is based in the Drama department at Queen Mary University, London. Her research explores the use of a new alter ego based on the seventeenth-century controversial messianic figure of Shabbtai Zevi who converted from Judaism to Islam and the contentious subject of his followers' descendants, the Dönmeh, in present-day Turkey. Ashery has been involved with educational work for many years, including public art and community based projects, as well as teaching and running workshops in academic contexts.

Nonel

Brought up on a heady mixture of Hebrew, Arabic, Yiddish and English, as well as sharing many tears with her dad every Friday lunch time whilst watching Egyptian movies together, had contributed to Nonel's perception of art as a mobilising tool of an already unstable gender, language and political grounds. Leaving his artistic calling behind, due to a creativity-killing virus, Nonel, together with his lifelong colleague and peer, Vovel, have set out to successfully save Palestine. This unexpected victory as a first-time superhero has paved the way to Nonel's conceptualizing and founding of the only Non-Occupying Israel Simulacra East (NOISE) village on the Saadiyat Island. Village NOISE has proven to be a remarkable economical, agricultural, and lifestyle enhancing model for which Nonel won a Nobel Prize. Nonel went on to surprisingly win the Intergalactic Alternative Sci-Fi Jew Beauty Contest, in what later came to be known as the famous Pre-Fixed Contest. As a result of that Nonel went into hiding and only recently has returned to the public's attention with a successful one-hero show featuring the 7-Sense infinite display *Untitled*.

Larissa Sansour. Born in Jerusalem, Sansour studied Fine Art in Copenhagen, London and New York, and earned her MA from New York University. Her work is interdisciplinary, immersed in the current political dialogue and utilises video art, photography, experimental documentary, the book form and the internet.

Sansour borrows heavily from the language of film and pop culture. By approximating the nature, reality and complexity of life in Palestine and the Middle East in general to visual forms normally associated with entertainment and televised pastime, her grandiose and often humorous schemes clash with the gravity expected from works commenting on the region. References and details ranging from sci-fi and spaghetti westerns to horror films converge with Middle East politics and social issues to create intricate parallel universes in which a new value system can be decoded.

Sansour's work has been exhibited worldwide in international biennials, galleries, museums, film festivals and on the internet and is featured in many art publications. Her most notable shows include the Tate Modern in London and Arken Museum of Modern Art in Denmark.

In 2008, her work featured in the Third Guangzhou Triennial in China, the Busan Biennale in South Korea and PhotoCairo4 in Egypt. Her most recent film *A Space Exodus* was nominated in the short film category at the Dubai International Film Festival.
The list of shows for 2009 includes the 11th International Istanbul Biennial and Art Dubai. Sansour's first ever solo show in New York is scheduled for late 2009.

In addition, Sansour is the curator of several screening programs as well as a frequent lecturer at various institutions in Europe, the US and the Middle East. She lives and works in Copenhagen, Denmark.

Vovel
Formerly known in the outskirts of elitist circles a political artist of moderate importance, Vovel is now mainly acknowledged for her intergalactic efforts to save the universe as we know it – as well as other universes like it. Having gained global fame by uncovering an extraterrestrial plot to reduce The Holy Land to a reservoir and subsequently bringing an end to the internationally ignored Israeli occupation of Palestine in a series of spectacular interventions with fellow ex-artist Nonel, she went on to become the first earthling to barhop the Milky Way.
After several years as CEO of the Palestinian Space Agency, she went on to create and host the wildly successful reality show *Arabs in Orbit*. She is also founder of the first Universal Superhero Academy in Jerusalem X on Planet Palestine.
In recent years, Vovel has returned to her original calling – fine art. Her most notable shows include the Sea of Tranquility Biennial on the lunar surface as well as a solo show at the Little Green Man Gallery on Mars.

Concept
Oreet Ashery and Larissa Sansour

Design Coordination
Gabriele Nason, Daniela Meda

Editorial Coordination
Filomena Moscatelli

Copyediting
Emily Ligniti

Copywriting and Press Office
Silvia Palombi Arte&Mostre, Milano

US Editorial Director
Francesca Sorace

Promotion and Web
Monica D'Emidio

Distribution
Antonia De Besi

Administration
Grazia De Giosa

Warehouse and Outlet
Roberto Curiale

Photo Credits
Vanda Playford
Tate Modern and Royal Free Hospital

Søren Lind
Imperial War Museum and in Palestine

Stephen Wilson
Edgware Road

Edizioni Charta srl
Milano
via della Moscova, 27 - 20121
Tel. +39-026598098/026598200
Fax +39-026598577
e-mail: charta@ chartaartbooks.it

Charta Books Ltd.
New York City
Tribeca Office
Tel. +1-313-406-8468
e-mail: international@chartaartbooks.it
www.chartaartbooks.it

All images and texts in the book are by the artists and co-authors Oreet Ashery and Larissa Sansour, unless otherwise indicated.

Virus Story illustrations

Chapter 2, *The Lab Calls*
Ada Ortega Camara

Chapter 3, *The Bug Spilled*, original drawings
Vojislav Radovanović

Chapter 4, *Symptoms*
James Pyman

Chapter 5, *Powers Versus Creativity*
Shira Derman

Chapter 6, *What Shall We Do?*
Jason Elvis Barker

Chapter 7, *Palestine, Here We Come*
James Pyman

Intergalactic Palestine
Written by Søren Lind
Illustrated by Hiro Enoki
Colouring assistance by Semi-Detached

Thanks for the continuous support of our families, friends, peers and colleagues. Special thanks to the Live Art Development Agency for their ongoing advice.
Thanks to Stephen Wilson, Anjalika Sagar and Omar El-Khairy for their input.
A special thank you to Søren Lind for his tremendous help and invaluable input.

www.nonelandvovel.net

Arts & Humanities
Research Council

LOTTERY FUNDED

KUNSTRÅDET
Danish Arts Council

Live Art
Development
Agency

Queen Mary
University of London

To find out more about Charta, and to learn
about our most recent publications, visit

www.chartaartbooks.it

Printed in June 2009
by Tipografia Rumor, Vicenza
for Edizioni Charta